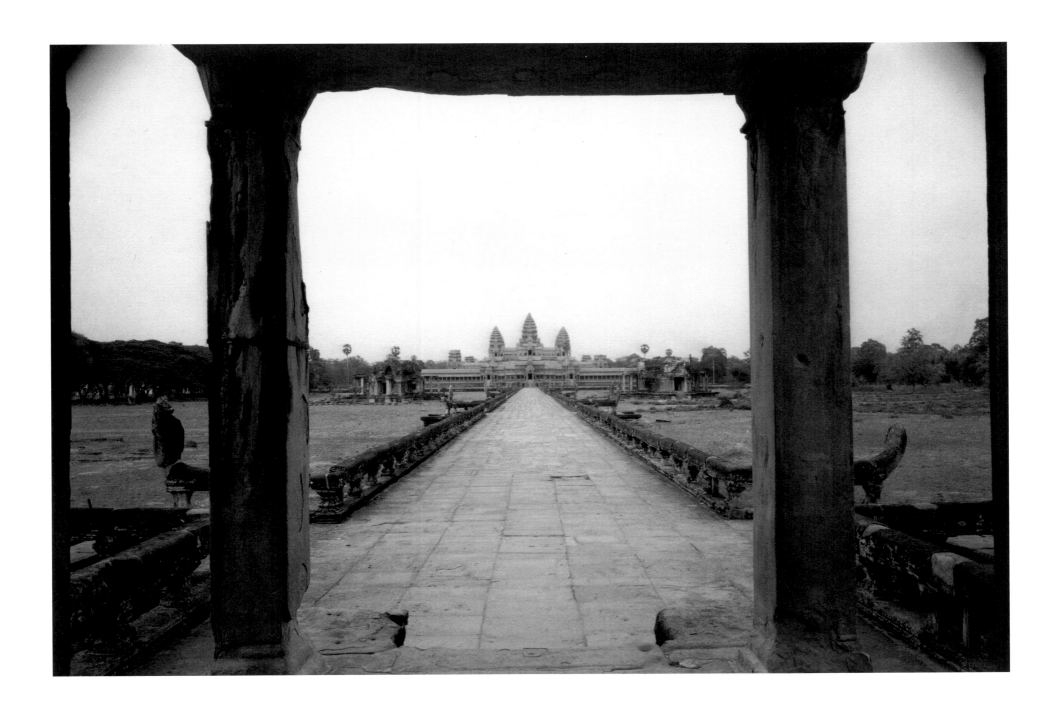

To the children of Cambodia
and the staff of the Angkor Hospital for Children / Friends Without A Border,
the inspiration of life and love.

Angkor Hospital for Children was founded by photographer Kenro Izu, who was deeply moved by his encounters with children during a series of photographic trips to Cambodia's Angkor monuments. As a way of returning something to the children of this country – Izu created Friends Without A Border, dedicated to building and operating Angkor Hospital for Children.

All proceeds from the sale of this book help Angkor Hospital for Children provide urgently needed health services to children in Cambodia.

KENRO IZU

Passage to Angkor

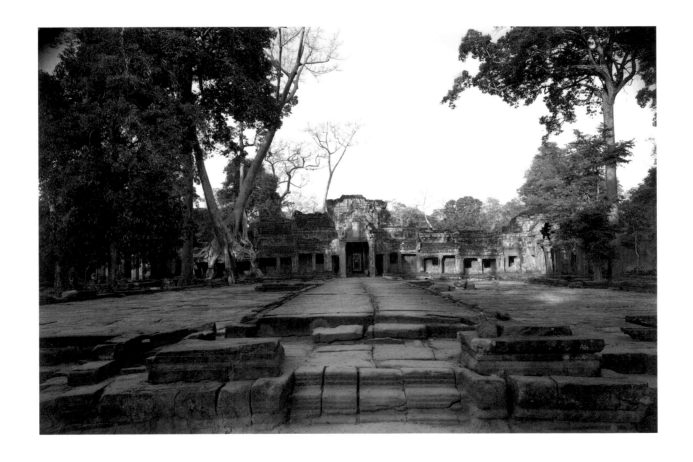

INTRODUCTION AND POEMS BY HELEN IBBITSON JESSUP

FRIENDS WITHOUT A BORDER

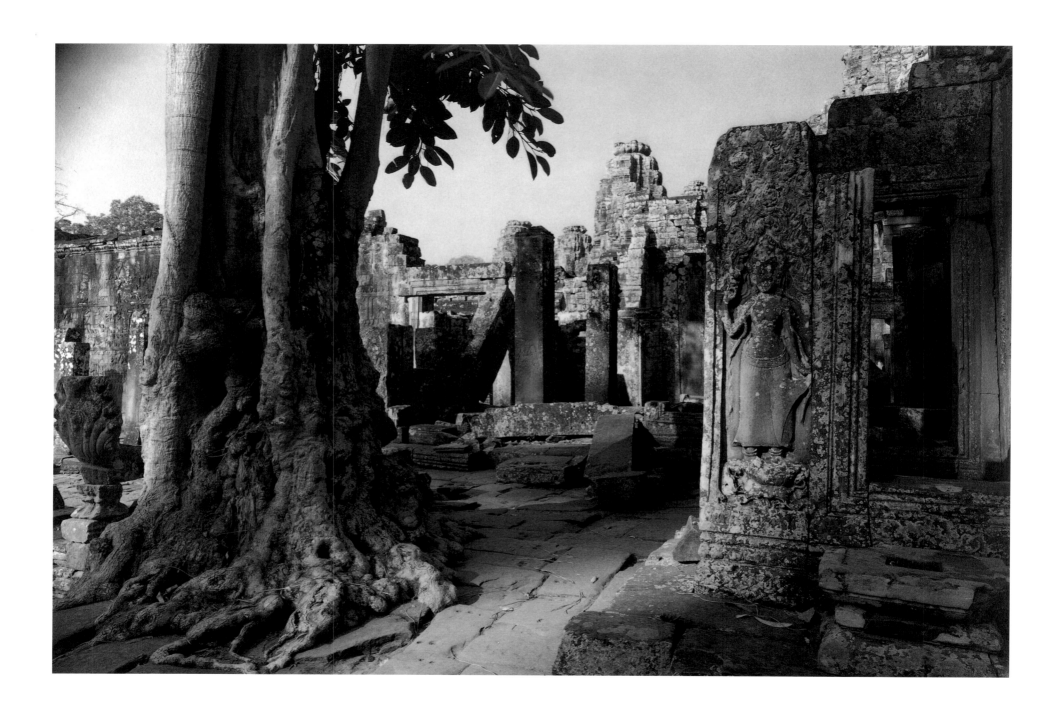

SPIRIT OF PLACE: THE GENIUS OF THE KHMERS

HELEN IBBITSON JESSUP

Just before dawn, the towers of Angkor Wat are inky shadows etched against the paling indigo of the tropical night. The first hint of dawn washes the sky with pink and reveals delicate mists wreathing the stones. The sun rises behind the temple's luxuriant forest, and the first rays gild the pinnacle of the central sanctuary. Gradually the light slides down the towers, bathing the walls and galleries, and strengthens from apricot to gold as the sun enriches the spectrum until the great monument glows from within. It is a transcendental experience.

Even without the romance of sunrise, or the more frequently watched sunset, when the towers are reflected in the ceremonial pools in front of the monument, Angkor Wat is overwhelming. We are awed by vast achievements like the pyramids of ancient Egypt and by the inspired blend of iconography, form, and spirituality of Java's Borobudur. We marvel at the triumphant harmony of mass and spatial rhythm in St. Peter's Basilica and at the exaltation negating gravity in Chartres Cathedral. All embody humankind's highest plastic achievements, where the expression of an ideal merges with and transcends technical skill. But none surpasses Angkor Wat, with its perfect fusion of symbolism, structure, and scale. Here the spirit soars, as the three dimensions are expanded by the awareness that the elements of time and motion were envisaged as integral to the fulfillment of the context: the inspired architect has orchestrated a scheme that depends on human participation for the full realization of the spatial potential.

This astonishing architectural masterpiece in Angkor, the capital of the Khmer Kingdom from the ninth century, was built in the first half of the twelfth century by Suryavarman II, who reigned from 1113 until mid-century. Its orientation is westward, the direction of death, in contrast to the eastward-facing situation of most Khmer temples, suggesting that it may have been a funerary monument for the monarch. It was dedicated to Vishnu, the Brahmanic god whom Suryavarman invoked as his protector, but since the fourteenth century it has been consecrated as a Buddhist temple. Its central enclosure area is approximately a mile square, its surrounding moat crossed by a causeway

with balustrades terminating in rearing *naga* heads. This quarter-mile ceremonial way leads to a series of concentric galleried courtyards rising to a central group of five towers, one at each corner and the highest, the central sanctuary, forming the peak of Cambodia's grandest temple-mountain.

Angkor Wat, the most magnificent religious structure ever conceived, is the apogee of Khmer attempts to represent the universe in architectural form. In countries influenced by Indic culture, in particular Cambodia, the temple-mountain was seen as the symbol of Mount Meru, the home of the gods of the Hindu pantheon and the center of their universe. Like that universe, it was surrounded by water representing the cosmic ocean in the form of its wide moat. Earlier Khmer expressions of the temple-mountain were on a less ambitious scale, beginning with the small temple of Ak Yum, now a ruin partly engulfed by the rampart of the west *baray*, a huge reservoir constructed in the eleventh century. The temple was a three-level pyramid built in the early eighth century.

Successive Cambodian monarchs typically constructed temples of which one, the state temple dedicated to a protective deity, was a temple-mountain, often comprising five levels in pyramid form surmounted by a group of five towers, as at Angkor Wat. Such powerful monuments as Bakong (dedicated in 881 in the pre-Angkor capital of Hariharalaya, now Roluos) and, in Angkor itself, Bakheng (early tenth century), Pre Rup (961), Ta Keo (early eleventh century), Baphuon (around 1060), and others preceded Angkor Wat. The last great temple-mountain was Bayon, built at the end of the twelfth century as the physical and spiritual center of Jayavarman VII's capital city of Angkor Thom. Its forty-nine towers and central sanctuary tower are carved on their four cardinal facades with a calm face whose identity is speculative but who is probably the Bodhisattva Lokeshvara, radiating benevolence and watchfulness over Jayavarman's realm. These enigmatic towers embody the essence of one of the world's most compelling religious monuments.

In their evolving mastery first of brick with stucco decorations, then of laterite, and finally of sandstone, and sometimes a combination of all three materials, the Khmers demonstrated consummate formal and technical skills. Finely chiseled colonettes and pilasters, lintels with intricate garlands and hieratic personages and animals, pediments with narrative scenes, doors, false doors, baluster windows, and elaborately framed niches housing guardian figures offer detailed elements in confident proportion to the scale of the monument. As early as the seventh century, the walls of the Sambor Prei Kuk temples in Takeo Province were enhanced by lively bas-reliefs depicting flying palaces with refined architectural details. The delicate

tracery and vitality of Banteay Srei's lintels and pediments; the graceful inventiveness of deeper relief showing *apsaras*, or celestial dancers, in myriad poses and fantastic headdresses; the architectonic sweep of the sculptured epics on Angkor Wat's galleries, almost half a mile in length; and the insights into Khmer life represented in the Bayon attest to Khmer sculptural genius. At the same time Khmer artists were carving freestanding, or *ronde-bosse*, sculpture of unparalleled iconic grace and humanism.

The Indian cultural influences apparent in Khmer architecture and sculpture reflect contacts that began early in our era. For information about Cambodian history before the oldest known local inscriptions of the sixth century, apart from what is enshrined in legend, we must draw on Chinese dynastic records of contacts with states having a trading or tributary relationship with the empire. Among the states mentioned are two that are represented in Chinese transliteration as Funan and Zhenla. Funan, a maritime state, occurs in annals from the third century and seems to have been centered on Angkor Borei in southern Cambodia. Zhenla was located farther north, possibly at Sambor Prei Kuk, and gradually became dominant from the sixth century. The Chinese envoy, Zhou Daguan (formerly Chou ta Kuan or Tcheou Ta Kuan), visited Angkor at the end of the thirteenth century and wrote an account of his stay that gives many insights into Khmer civilization in that period.

The nature of early states in Southeast Asia is not fully understood. Gradual migrations of Austronesian and Austroasiatic peoples from Yunnan to Southeast Asia probably occurred more than four thousand years ago. The emerging states were probably small, loosely structured chiefdoms at first, focused around market centers and lacking central control over wider areas. The Funan "kingdom" was perhaps more centralized, having a well-developed canal system linking the capital, Angkor Borei, with its port, Oc Eo. Chinese records describe the capital as a walled city with developed waterways, houses on stilts, and prosperous inhabitants who wore rich gold ornaments.

Archaeological finds demonstrate that Funan was one of the first regions in Southeast Asia to participate in the trading patterns that operated from the Mediterranean via India to China. Excavated objects include Indian artifacts and carnelian jewelry and dated silver coins from the Roman Empire. Cambodian myths of origin tell of a Brahman called

Kaundinya who arrived by sea, conquered the kingdom, and then married Soma, the daughter of the ruling serpent (naga) king. This legend can be seen as symbolizing the fusion of Indic and indigenous elements in Khmer culture, the more convincingly since a similar legend was preserved in the ancient kingdom of Champa in modern central Vietnam.

We are on more certain historical ground with stone inscriptions found in Cambodia, the earliest carved in Sanskrit verse but from the seventh century also incised in the Khmer language. The information in these inscriptions is almost exclusively religious and connected with temples serving the two great religions, Hinduism and Buddhism, that were the most visible influences of Indian civilization. The Sanskrit verse usually expresses the king's requests to a patron deity for protection and describes the monarch's genealogy and achievements, furnishing scant historical background. Khmer inscriptions, often found on the obverse side of a stele, are in prose, listing temple lands and chattels, and numbers of workers, dancers, and slaves serving the foundation, offering insights into the organization of religious and social life.

Since the evidence of epigraphy tends to be connected with temples, and since these were usually built by rulers, our knowledge of the Cambodian past is largely confined to royal history. Secular architecture, whether for kings or commoners, was made of perishable materials and has not survived, so it is only through sacred structures and their inscriptions that we can piece together the genealogies of the Khmer kings. Occasionally, bas-reliefs—such as those in the galleries of Angkor Wat and the Bayon that depict twelfth-century battles against invaders from Champa—illustrate historic events. Details on the lower registers of these galleries offer our only insight into the daily life of the Khmers. The upper panels of relief show monarchs and deities riding in triumph on elephants or in palanquins with naga-head finials, or long ships sweeping through the water carrying troops to battle. Below, the sculptors have depicted domestic scenes, where fish is cooked, bread is baked, women chat, and crowds watch cockfights. From these reliefs we learn also about the form of secular architecture in Cambodia; it seems to have been characterized by open pavilions with elegantly carved columns and roof eaves.

The 802 consecration on Mount Kulen of Jayavarman II as *cakravartin*, or universal monarch, signaled the beginning of the age of Angkor. The kingdom of the Khmers gradually expanded, although at times it also contracted as neighboring states resumed conquered territory, or as local chiefs exerted authority in regions within Cambodia. Under several monarchs the kingdom comprised parts of present-day Thailand, Laos, and southern and central Vietnam. At the end of the twelfth century, Jayavarman VII established a wide network of hermitages and hospitals, roads and bridges that stretched into

neighboring countries. By the era of the great narrative reliefs, the twelfth and early thirteenth centuries, evidence of Khmer authority could be found on stelae proclaiming royal edicts as far east as Lopburi in Thailand and as far north as Wat Phu in Laos. This authority, however, was probably exercised through a loose tributary relationship rather than through a central state resembling later colonial empires.

Although today we usually think of Khmer civilization in terms of Angkor, evidence of Cambodian architectural and sculptural genius is found in many other parts of the country (the eleventh-century Preah Vihear in the north, for example, Phnom Chisor in the south, and the seventh-century structures of Sambor Prei Kuk in the east), attesting to the pervasive nature of the high culture that was sustained for more than a thousand years. Even after the Thai conquest and the abandonment of Angkor in the fifteenth century, the Khmer dynasties that subsequently ruled from Phnom Penh continued a tradition of sculpture and architecture. While not as sublime or ambitious as when the empire was at its zenith, this work was nevertheless of impressive quality, particularly in the continuing traditions of wood sculpture.

Today, the erosion of neglect, the structural weakness inherent in spanning space with the unstable corbelled arch, and the mighty invasion of strangling trees all threaten the survival of one of the world's most precious artistic heritages. The romance of the forest's invasion, the unearthly beauty of the strange symbiosis of snakelike roots and noble pediments and pilasters, lends this unequalled expression of architectural genius an added drama. But we should not let the poetry of the scene blind us to the need to avert the crisis through sustained advocacy and support of conservation.

The incense is ash—
In saffron robes still kneeling
We wait for the dawn.

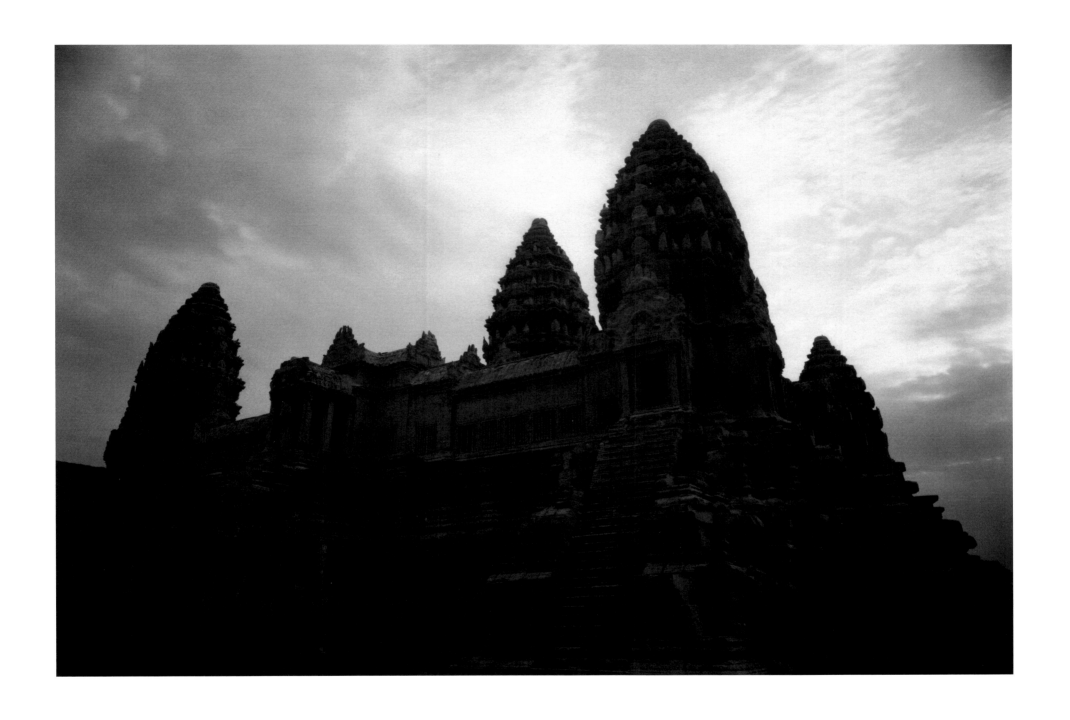

ANGKOR WAT, 1994 ANGKOR NO. 93

Five peaks of heaven soar
Beyond the earth's confining tomb,
Their secret cell the ebony womb
That breeds the linga's blazing core,
Invincible Shiva's flame.

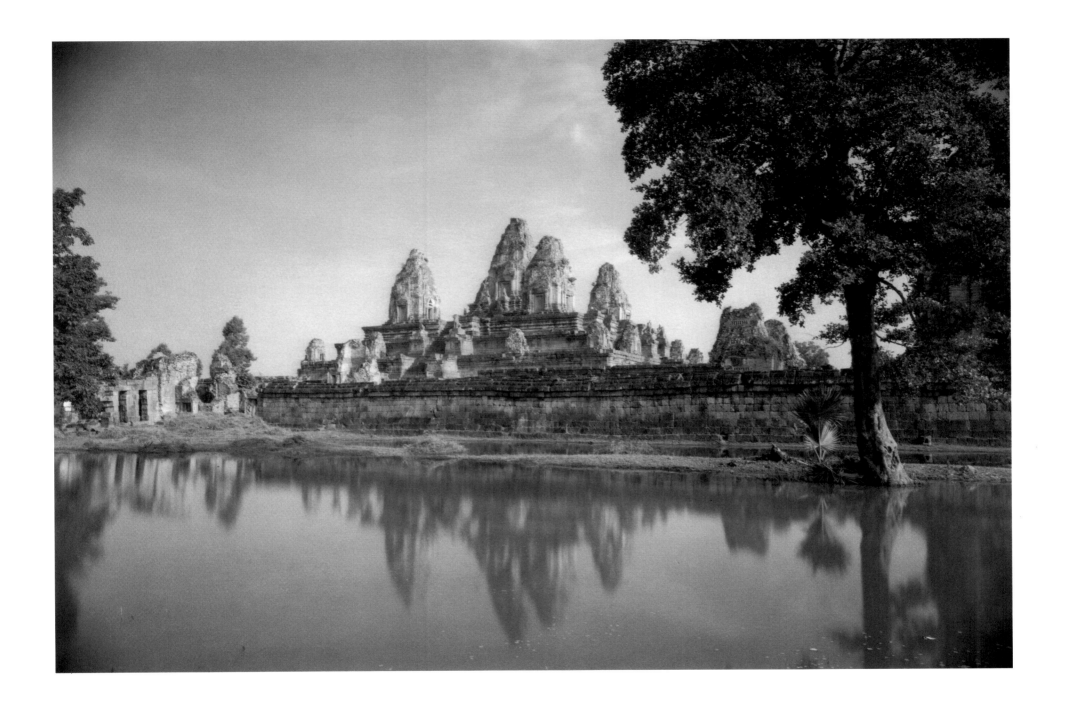

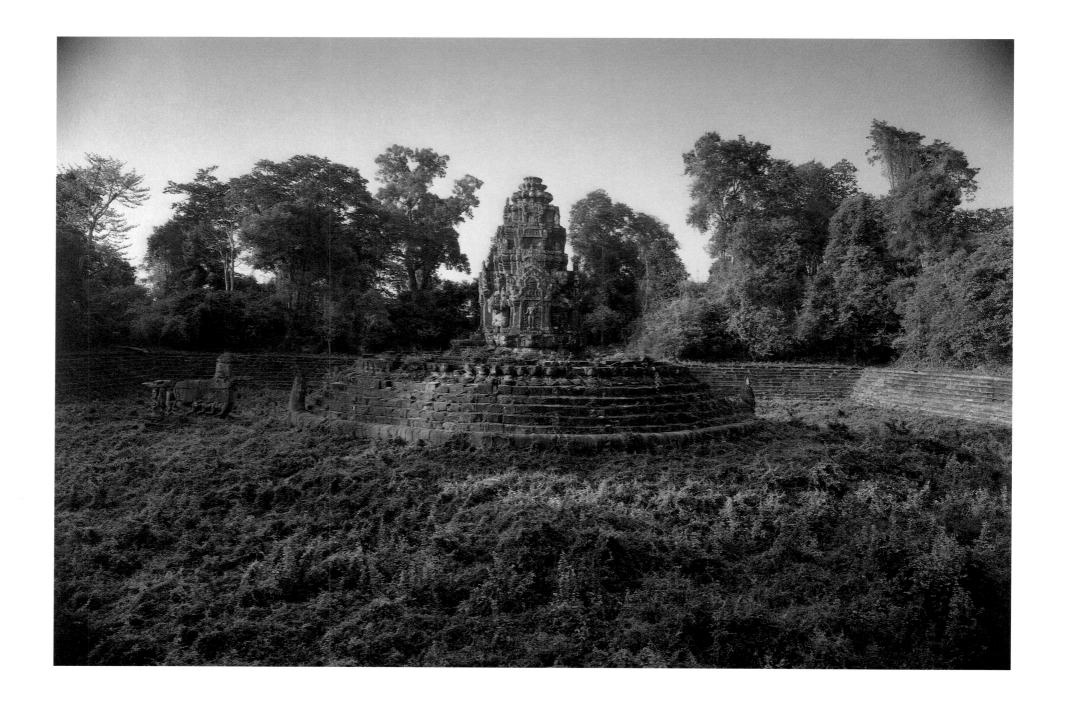

NEAK PEAN, 1993 ANGKOR NO. 10

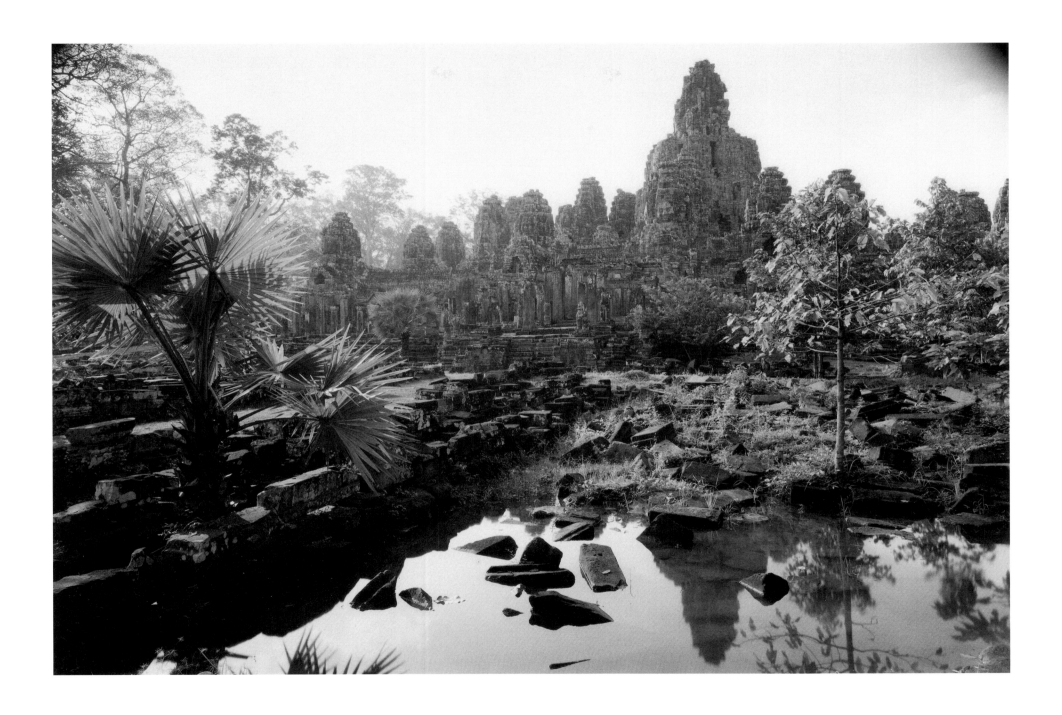

Enough, cried mother earth,
The sacred soil is mine.
Usurping kings will fade
Their hubris mocked by time.
My tree of life will thrive
Will clutch your boasting stones.
To conquer royal pride
The sinews of my roots
Will knot your royal bier.

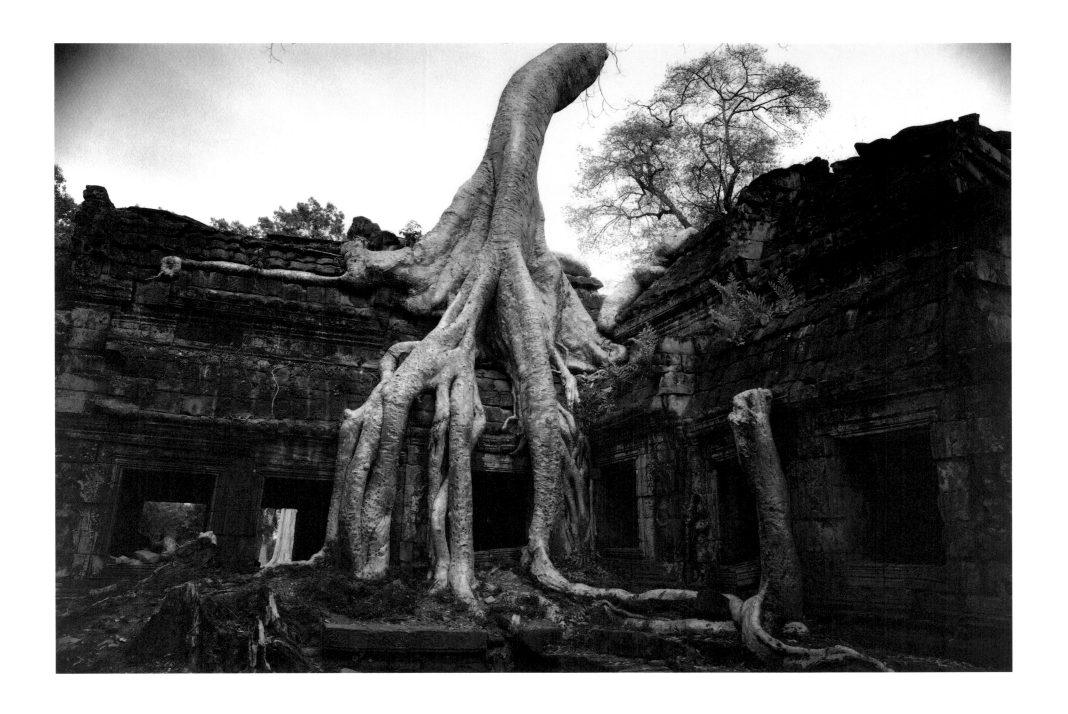

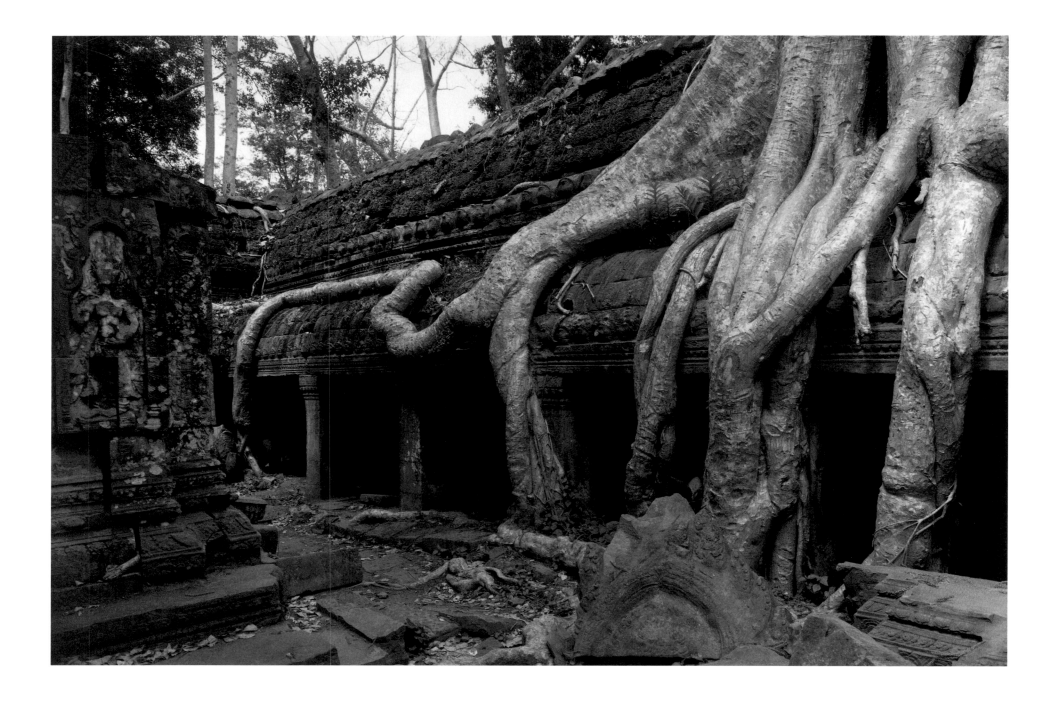

TA PROHM, 1993 ANGKOR NO. 15

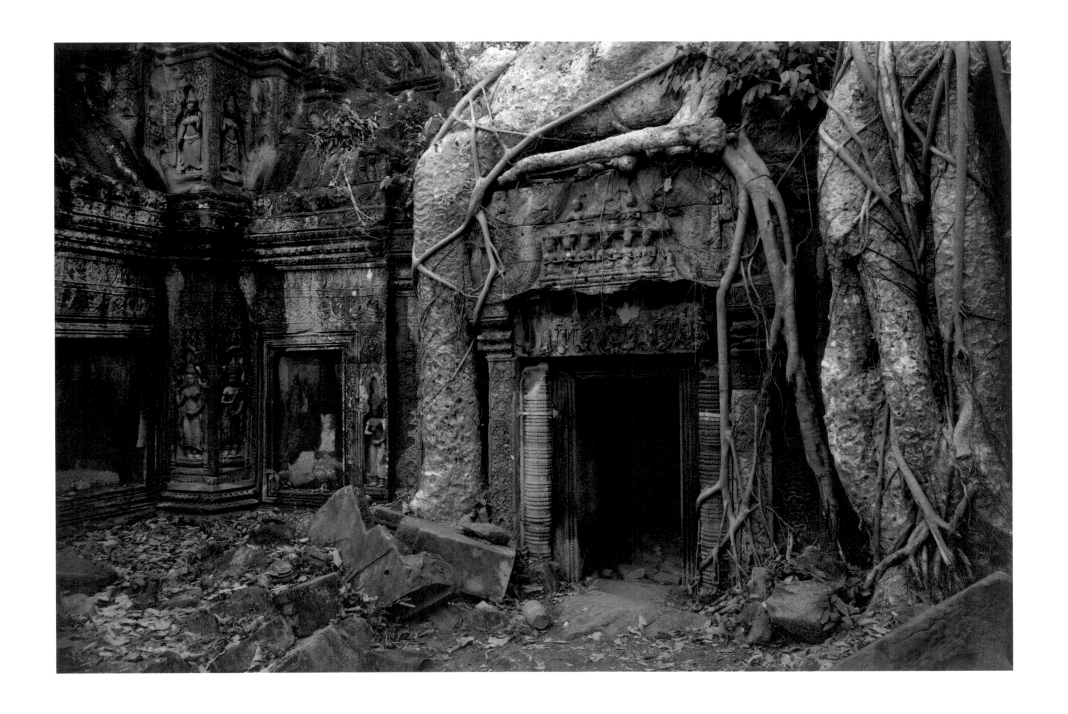

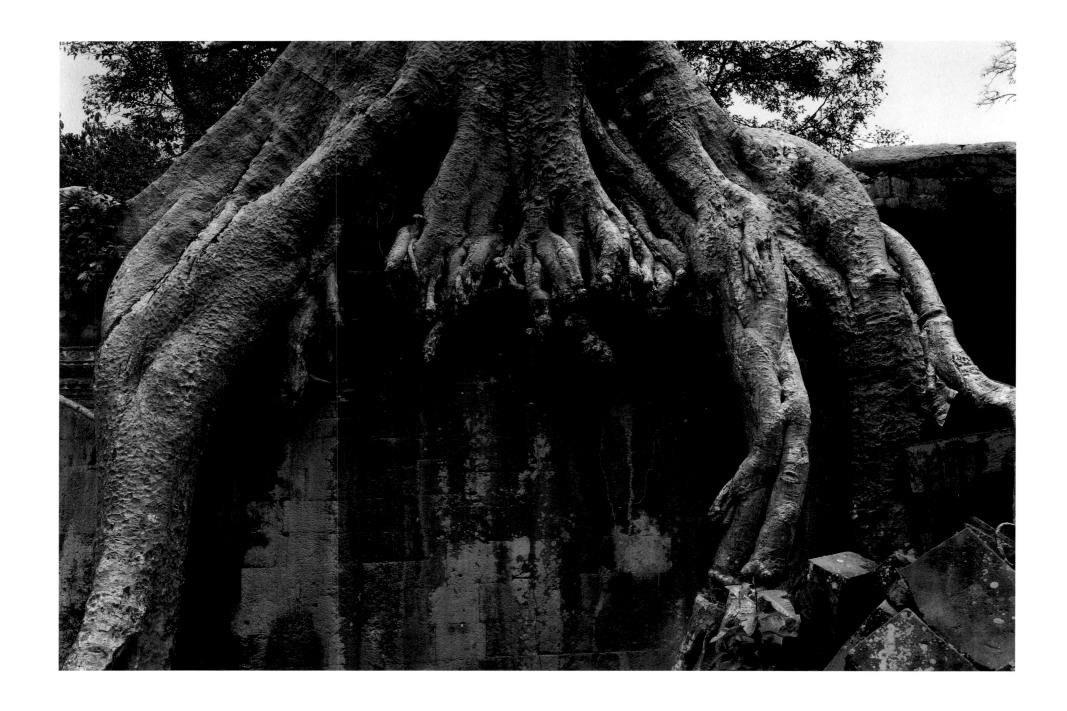

TA PROHM, 1993 ANGKOR NO. 16

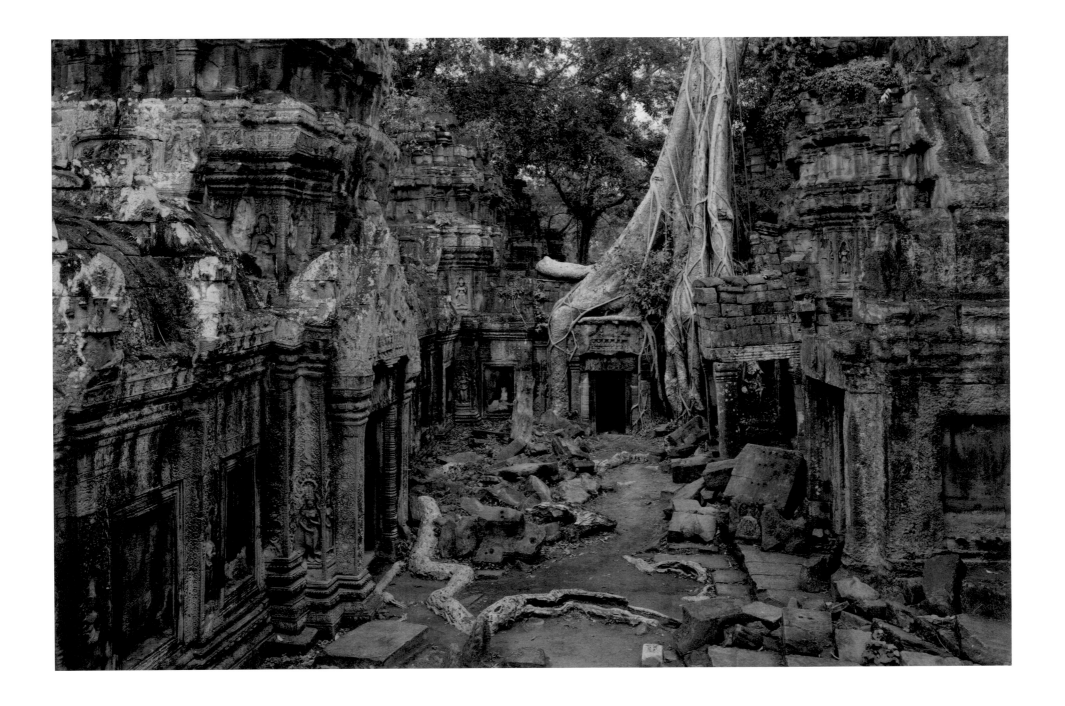

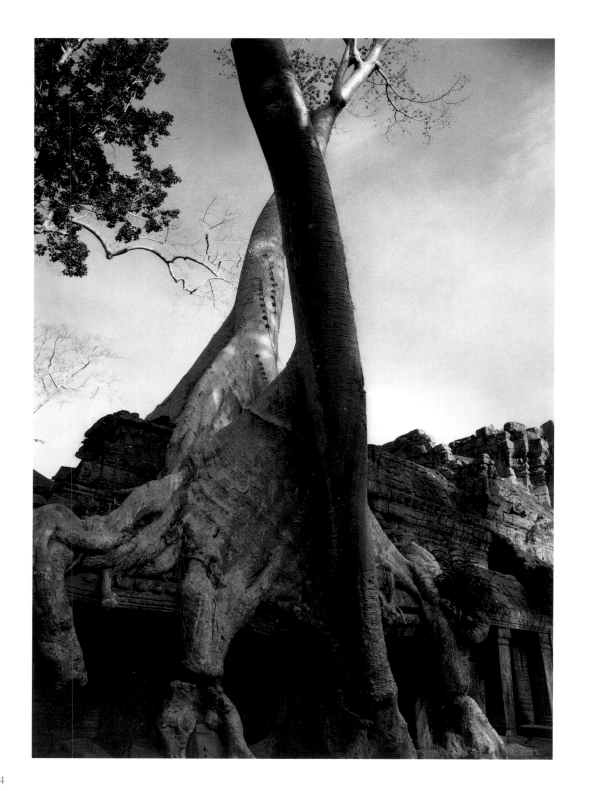

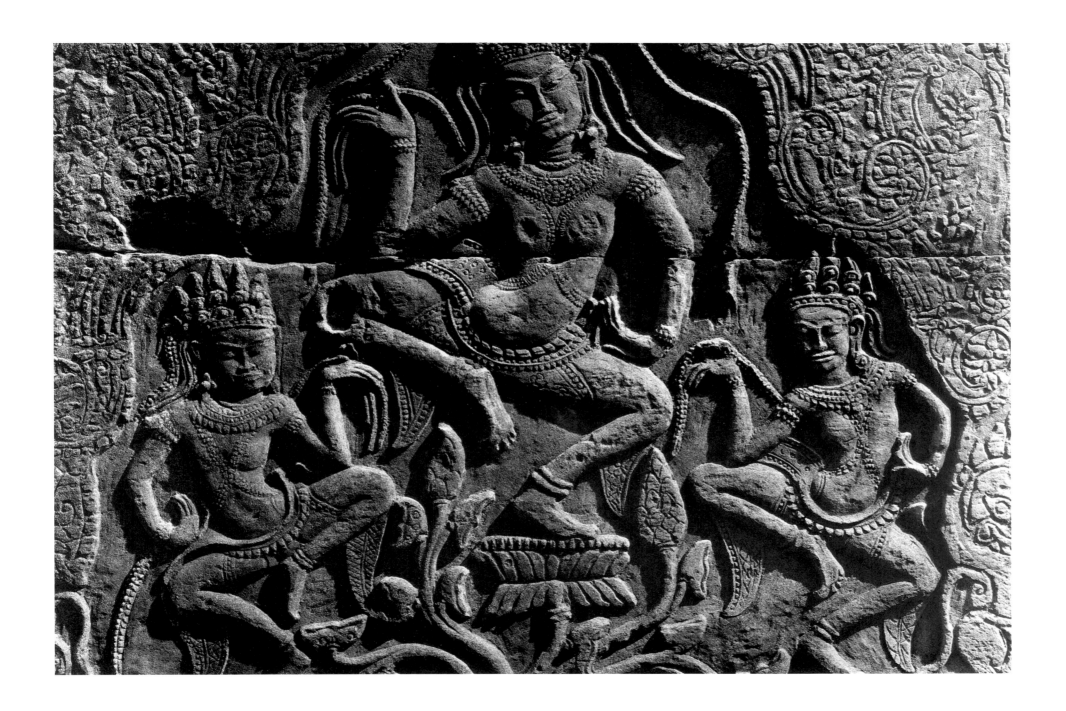

Nimble fingers wove your flowing tresses,
Bound them with blossoms and studded with glittering gems.
Now they are stilled, devoted skills forgotten,
Not dreaming your fragile blooms would long endure.
Forever the lotus bud will cup your secrets
Guarding the bliss inherent in your smiles.

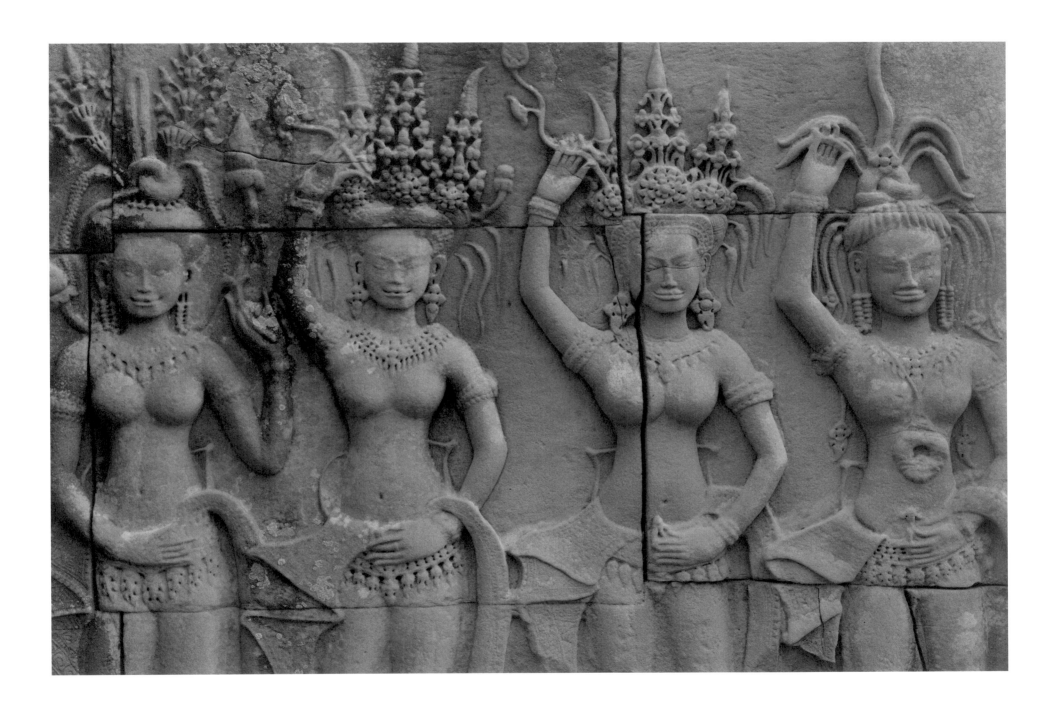

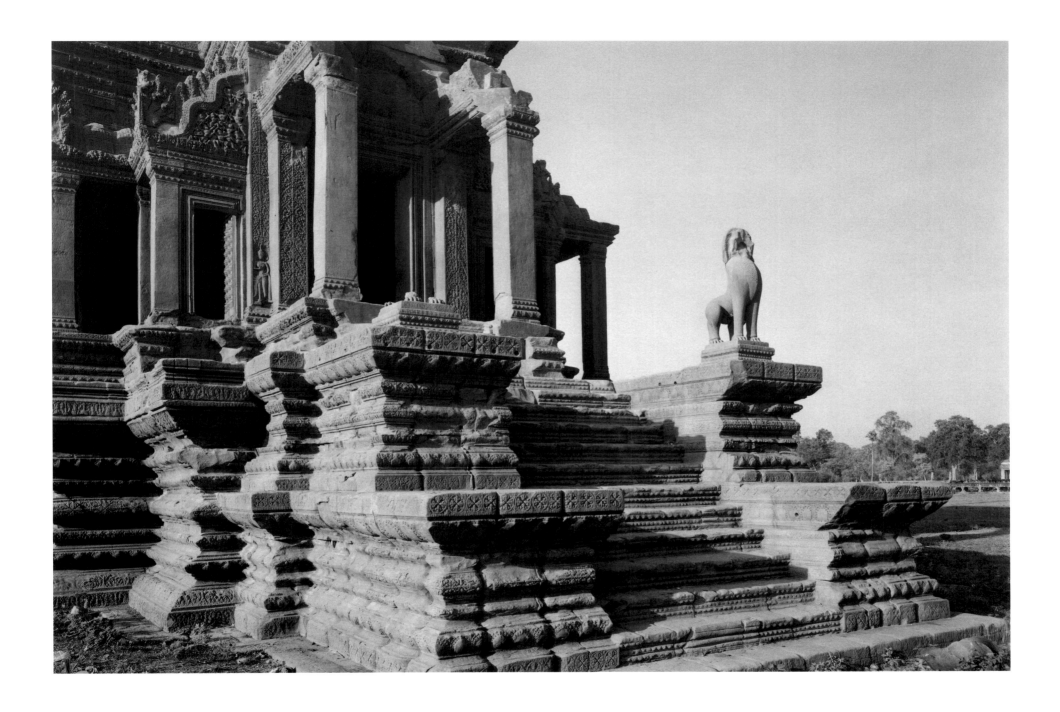

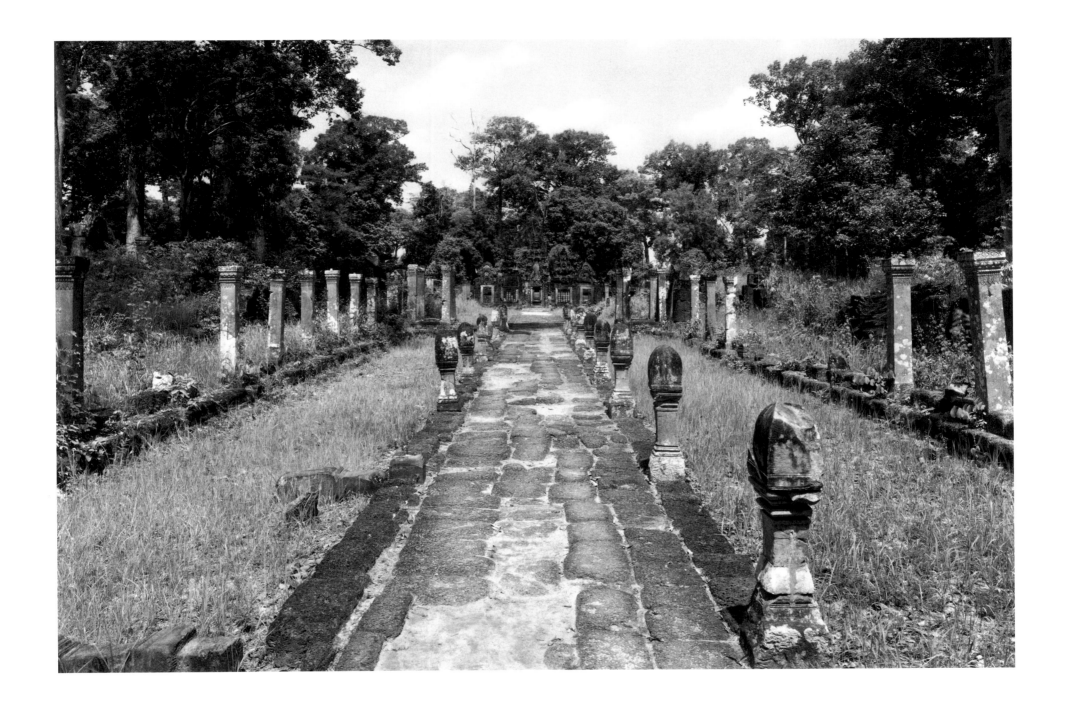

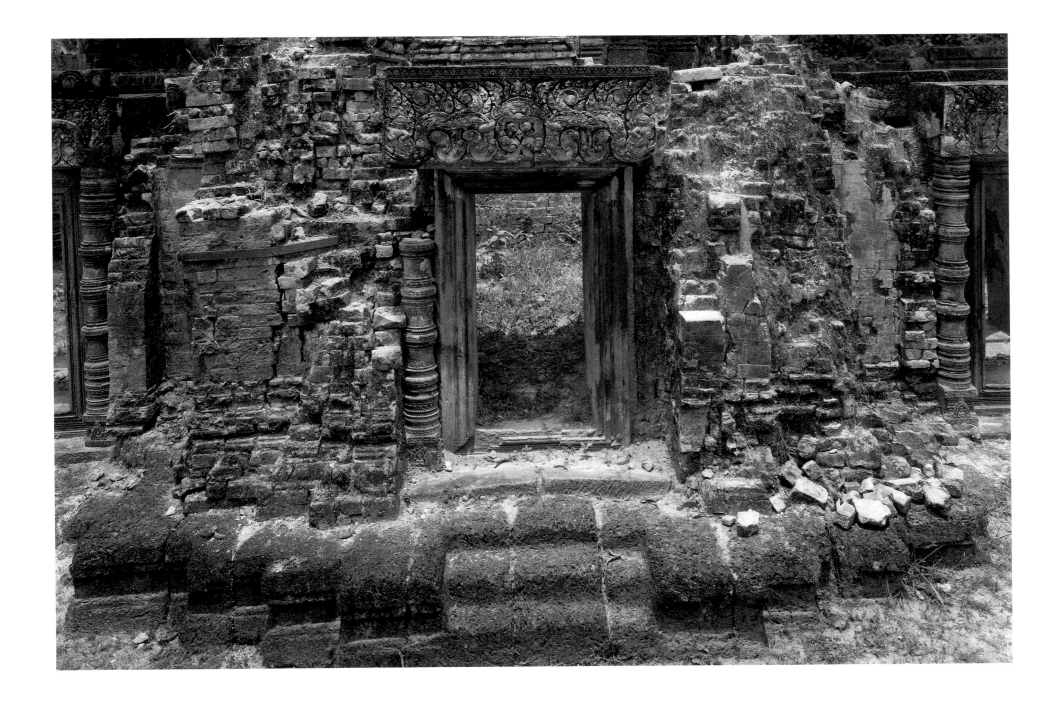

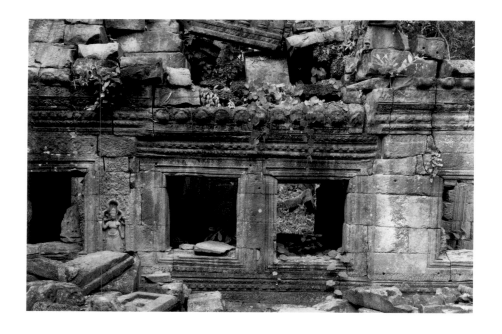

TA SOM, 1994 ANGKOR NO. 149

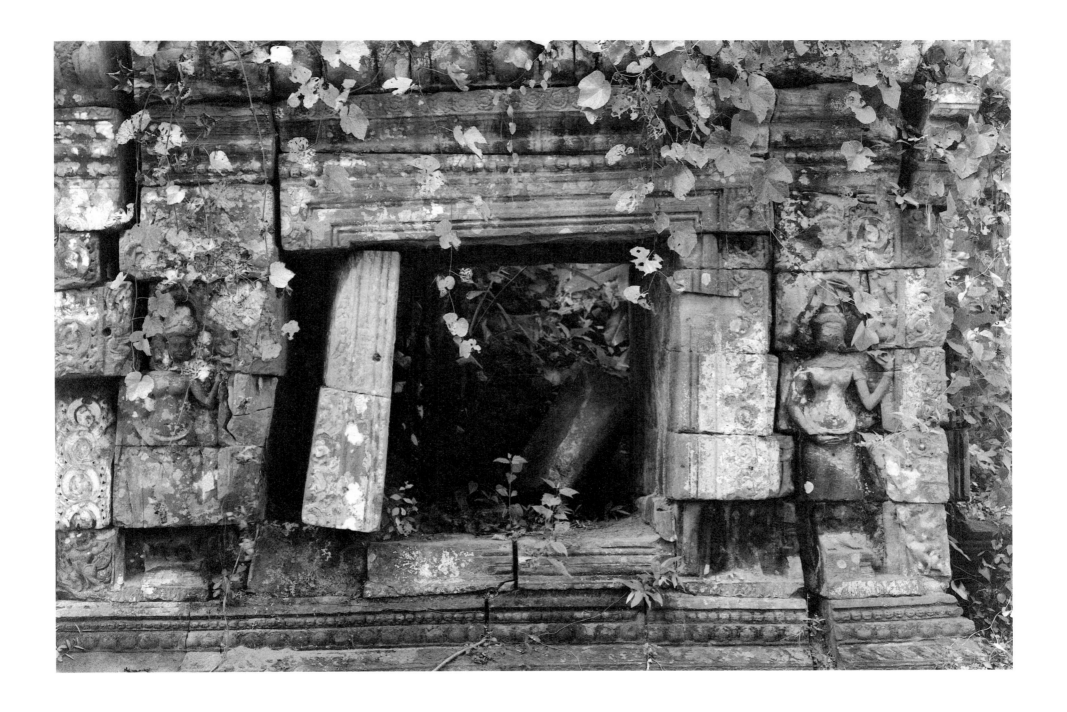

Cicadas' searing shrill has throbbed away
The sun's rays tepid now on time-worn stone.
This is the hour when apsaras return
Their slender forms will weave in suppliant dance,
Their brilliant silks will shimmer in the gloom,
Celestial nymphs who honor ancient gods.

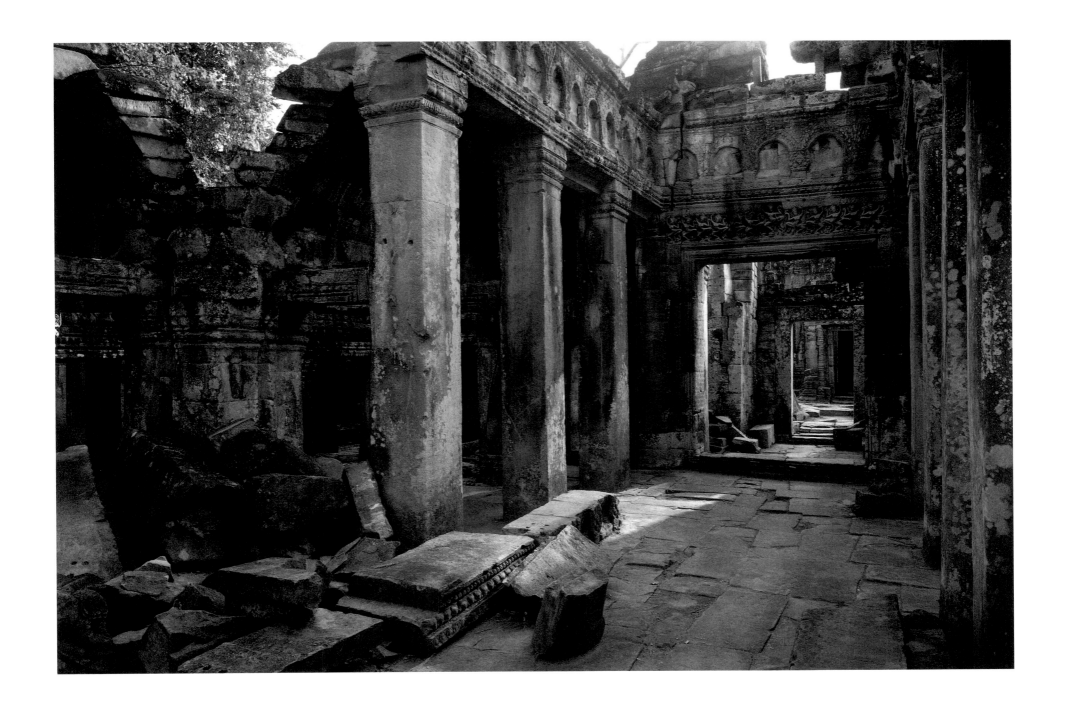

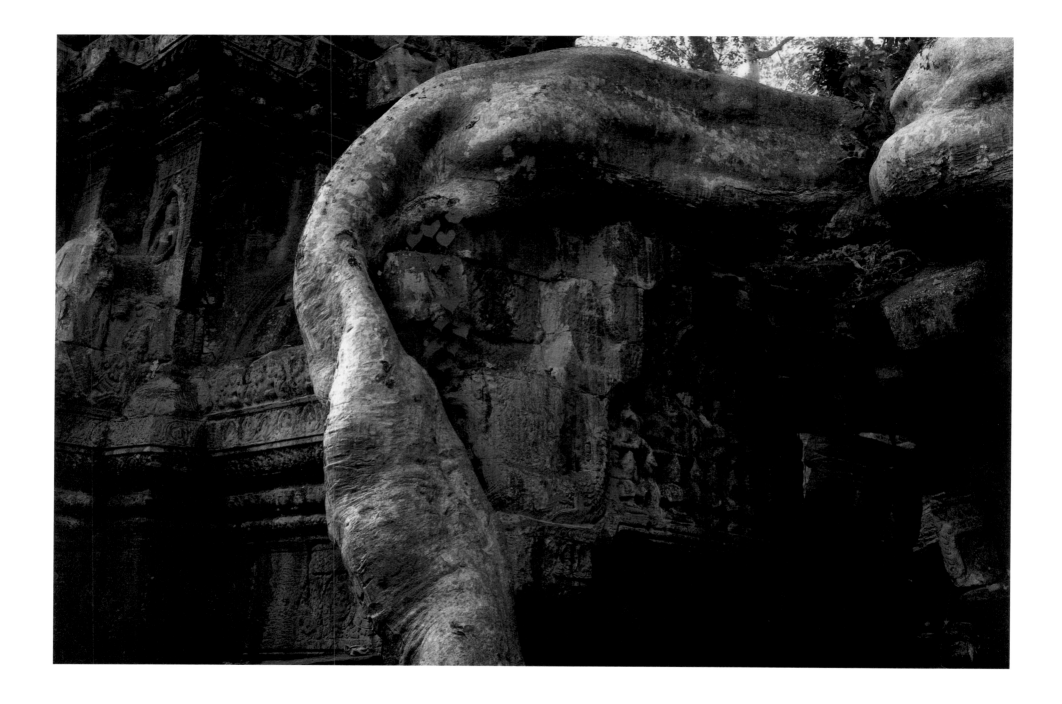

TA PROHM, 1994 ANGKOR NO. 155

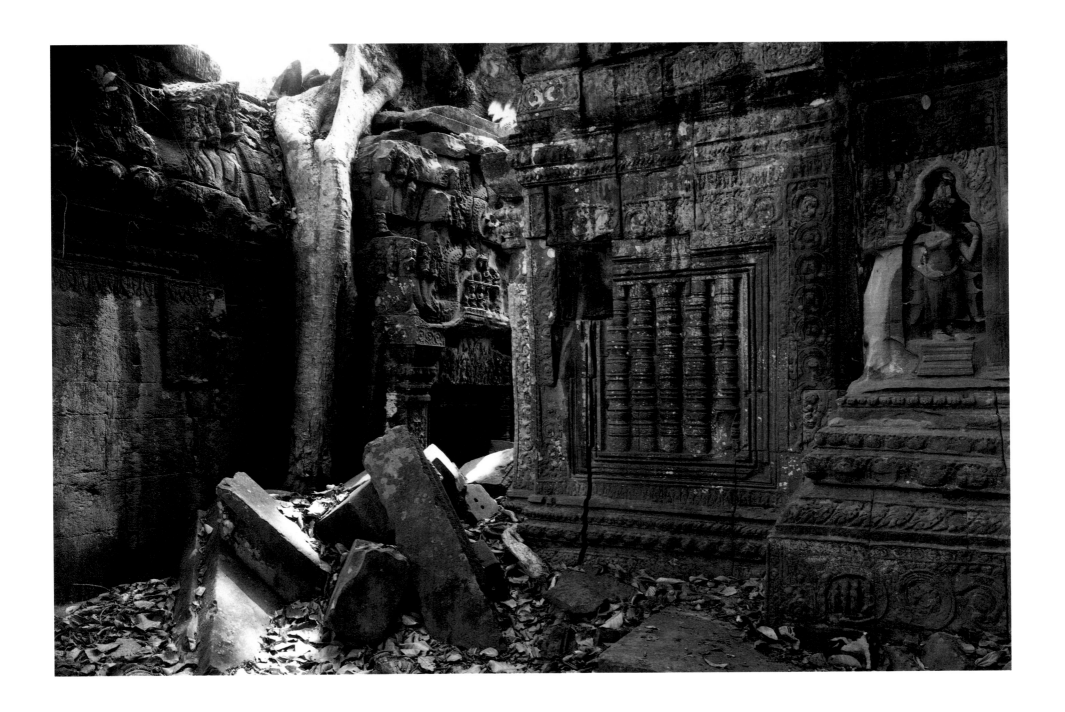

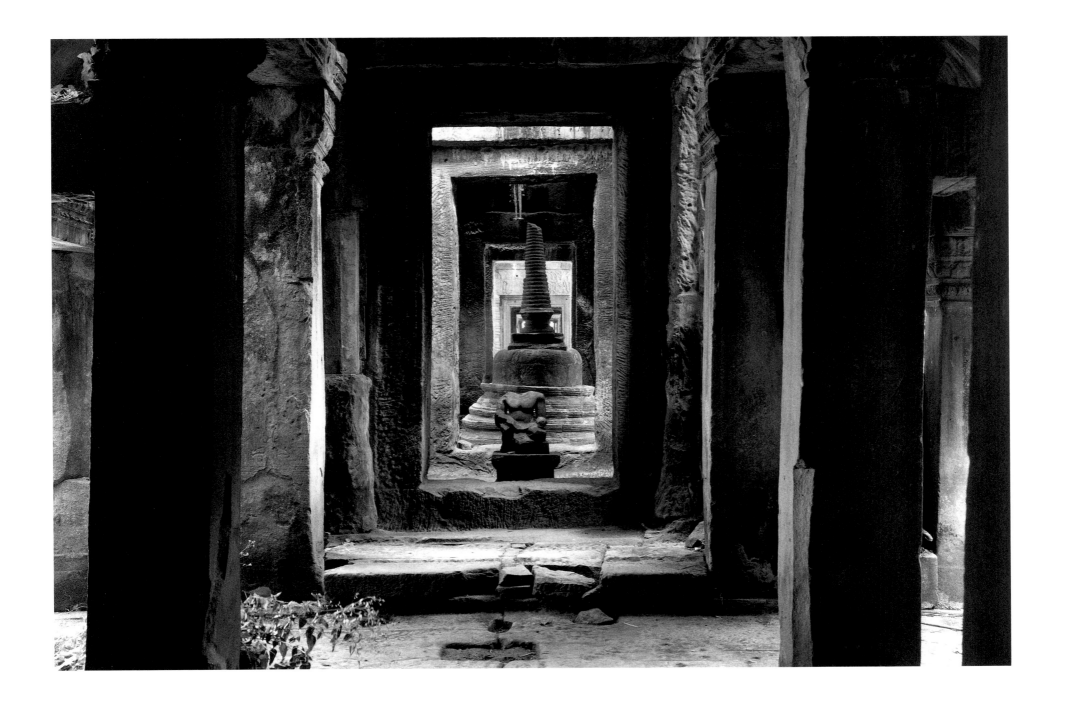

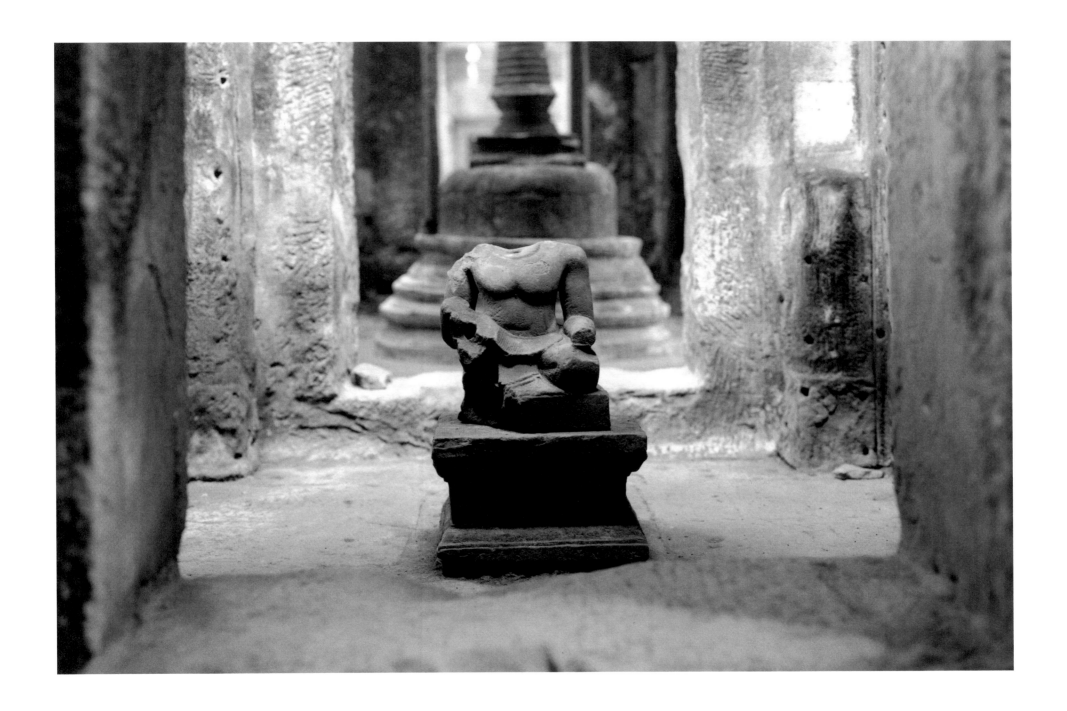

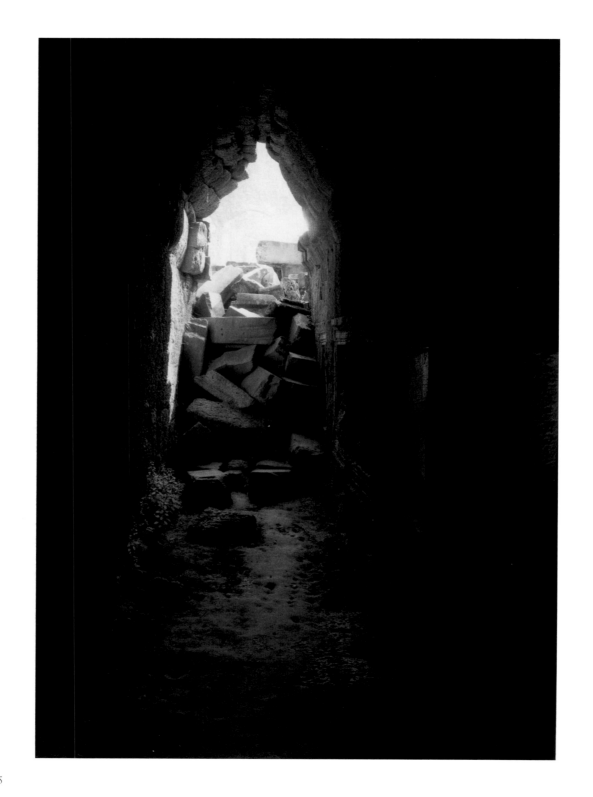

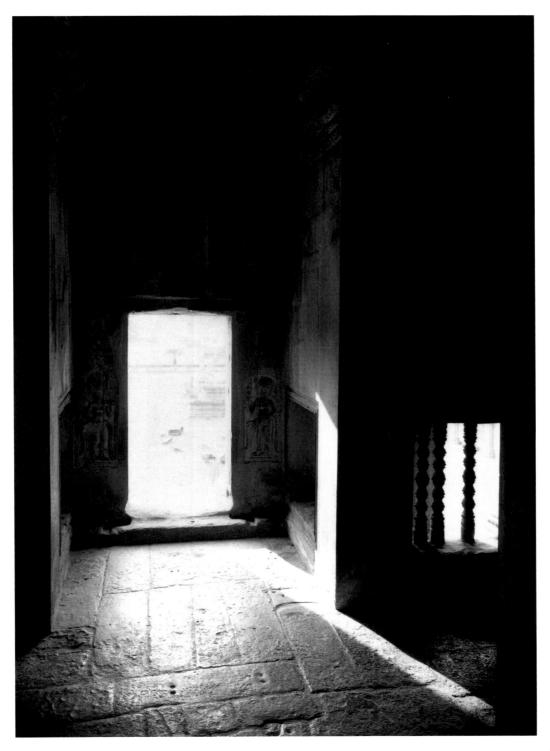

Down from the holy mountain stream
Blessed by a thousand lingas' power
The sacred waters lap your feet.
The lotus blooms to greet the sun
In daily prayer.

Serene you gaze at dawn and dusk
Awaiting the berth of royal barge,
Unwavering vigil long maintained
Suborned by unmarked tides of time
That scorn your care.

Your loyal heart will never know
That kings and consorts long have gone,
Their glories vanished with the years,
Their ancient ghosts dissolved in mist
In sightless stare.

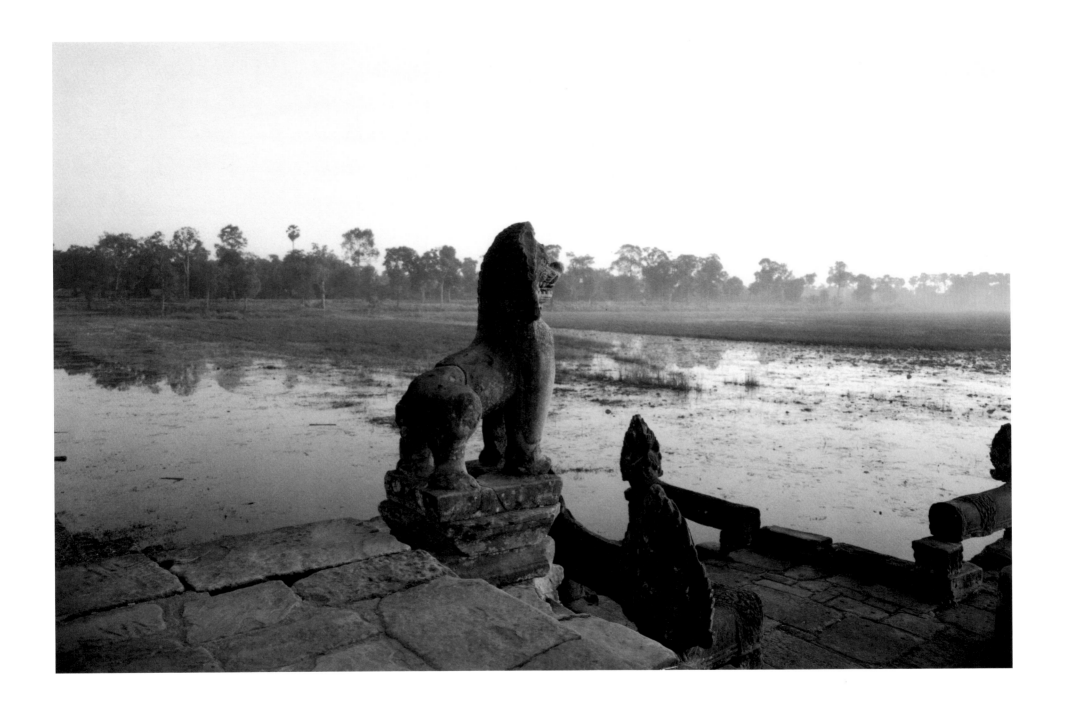

SRAH SRANG, 1994 ANGKOR NO. 143

Through the morning mists
Beating oars no longer splash
The prince will not come.

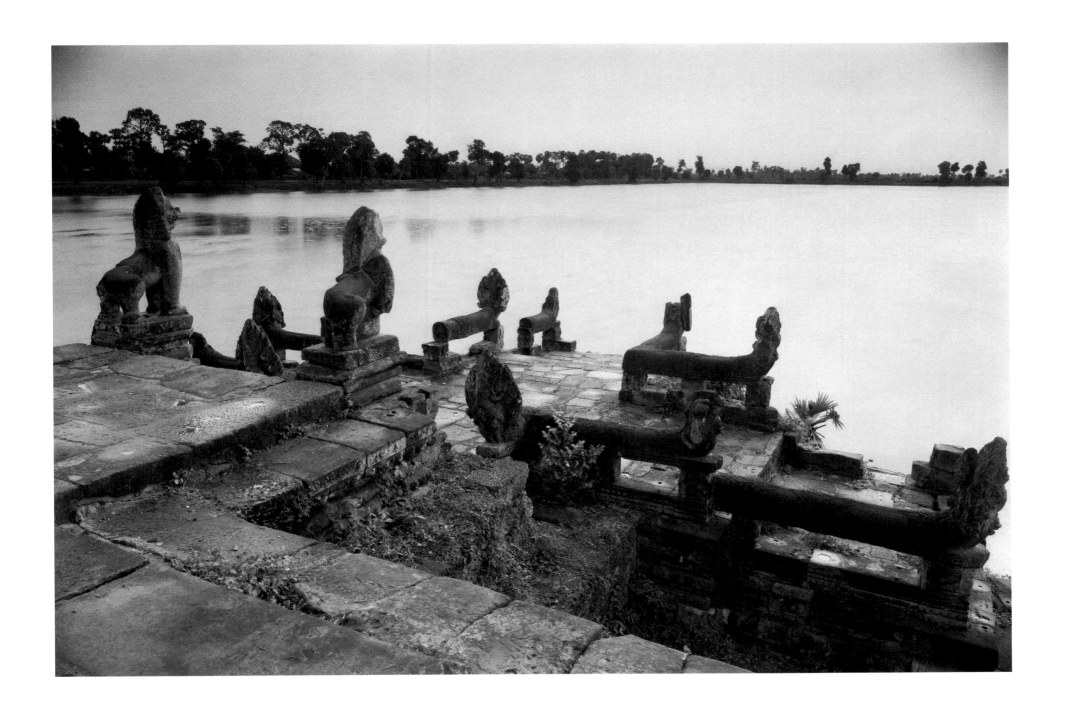

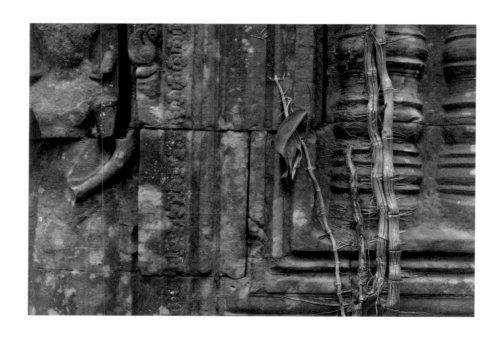

PREAH KAHN, 1994 ANGKOR NO. 72

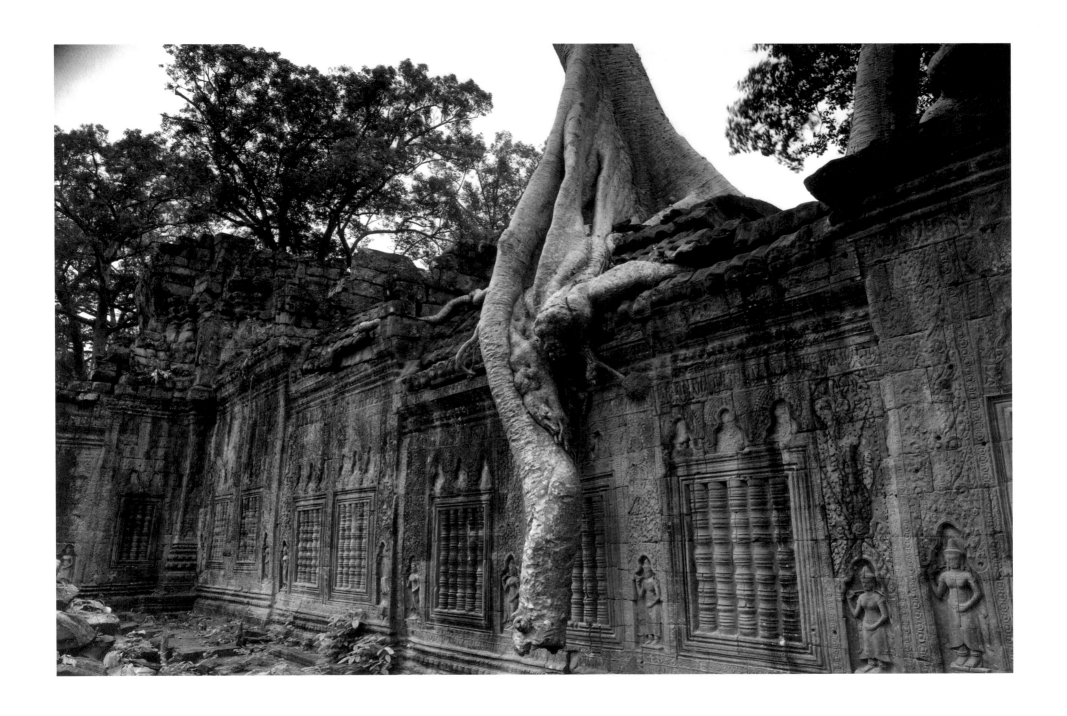

Who can know your name, almighty head,
Rearing in stone at Angkor's very heart?
Is it Lokeshvara's soul that blesses all,
Compassion streaming in your radiant gaze,
The bodhisattva's selfless gift to man
To nurture those who toil in earthly strife?
Or does the great god Brahma lie within
Creation latent in your secret smile,
Ranging the cosmos in your fourfold glance
Vigilant to guard the empire's core?
Perhaps the king himself is mirrored here,
The potent Jayavarman claiming all,
Invoking power from god and sage alike,
Triple divinity to challenge death.
Your smile's enigma holds the secret well
And triumphs over time's impending blow.

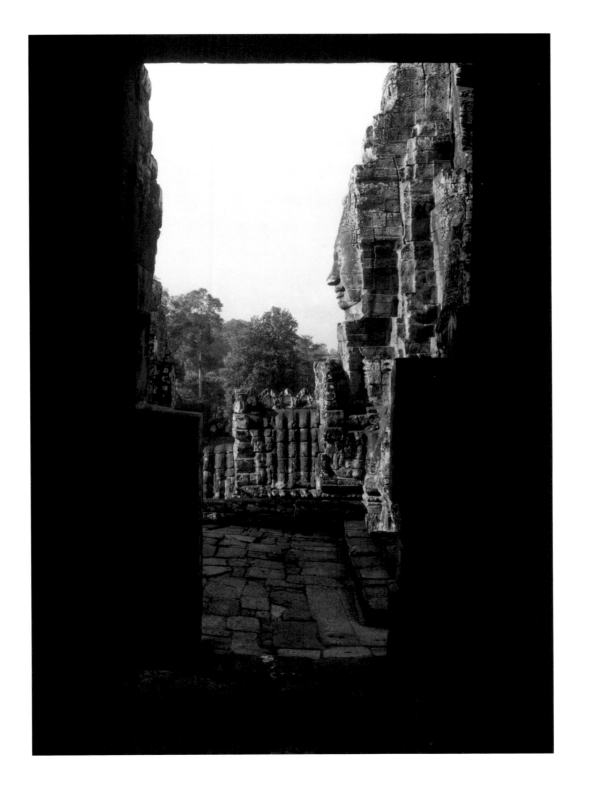

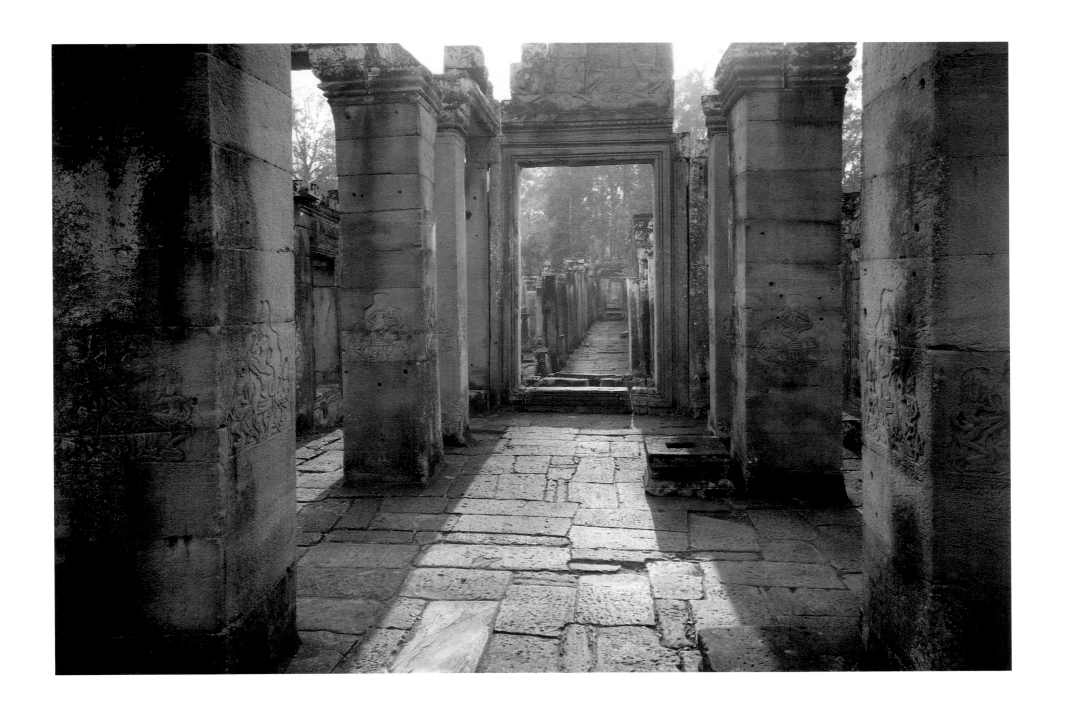

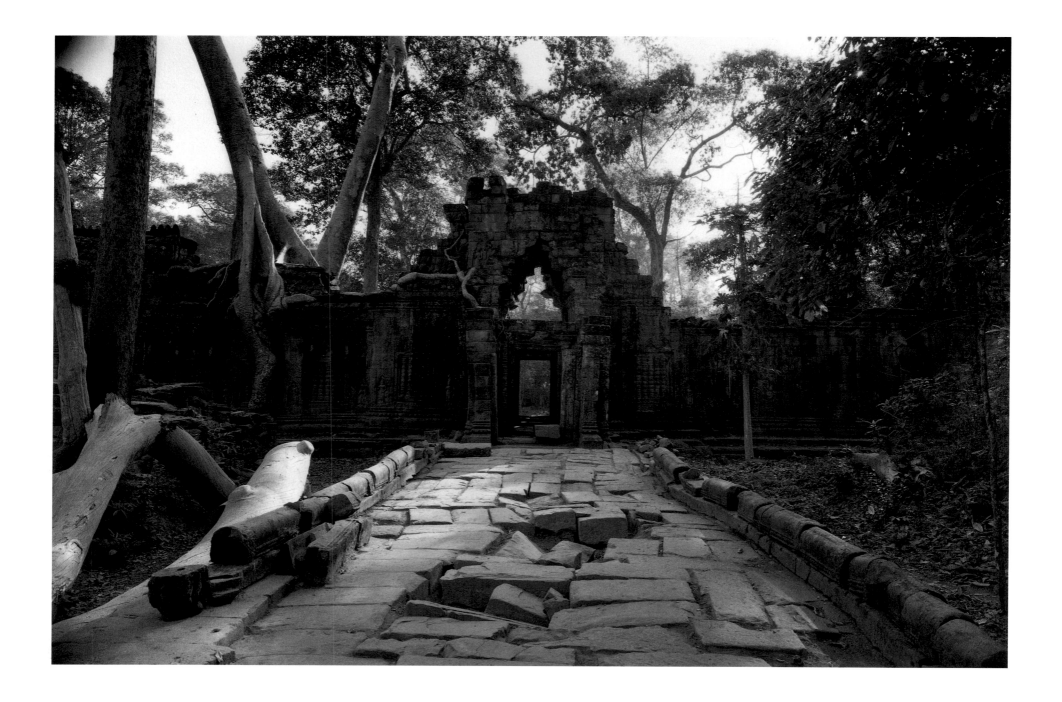

PREAH KAHN, 1996 ANGKOR NO. 242

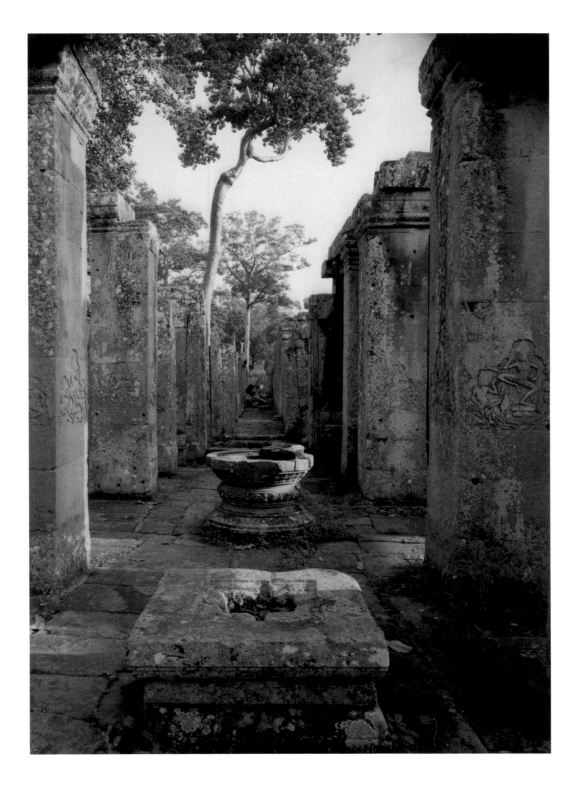

Who listens now to your heavenly song?
What goddess sways with your gliding steps?
Will great Vishnu you honored once
Redeem your evanescent smile?

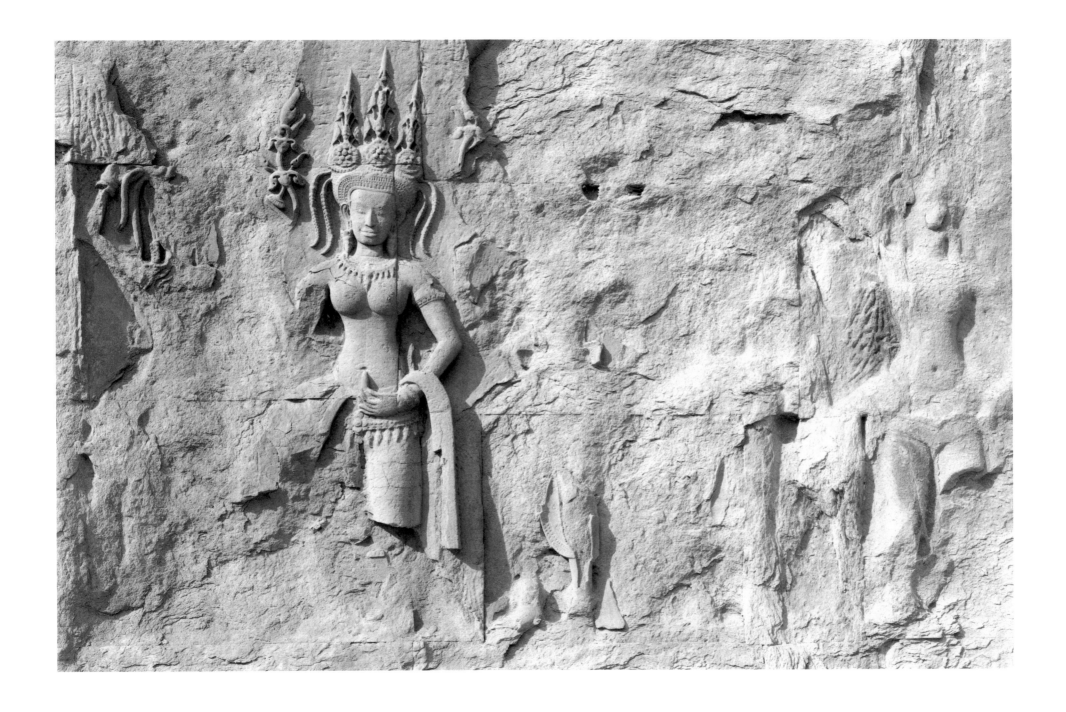

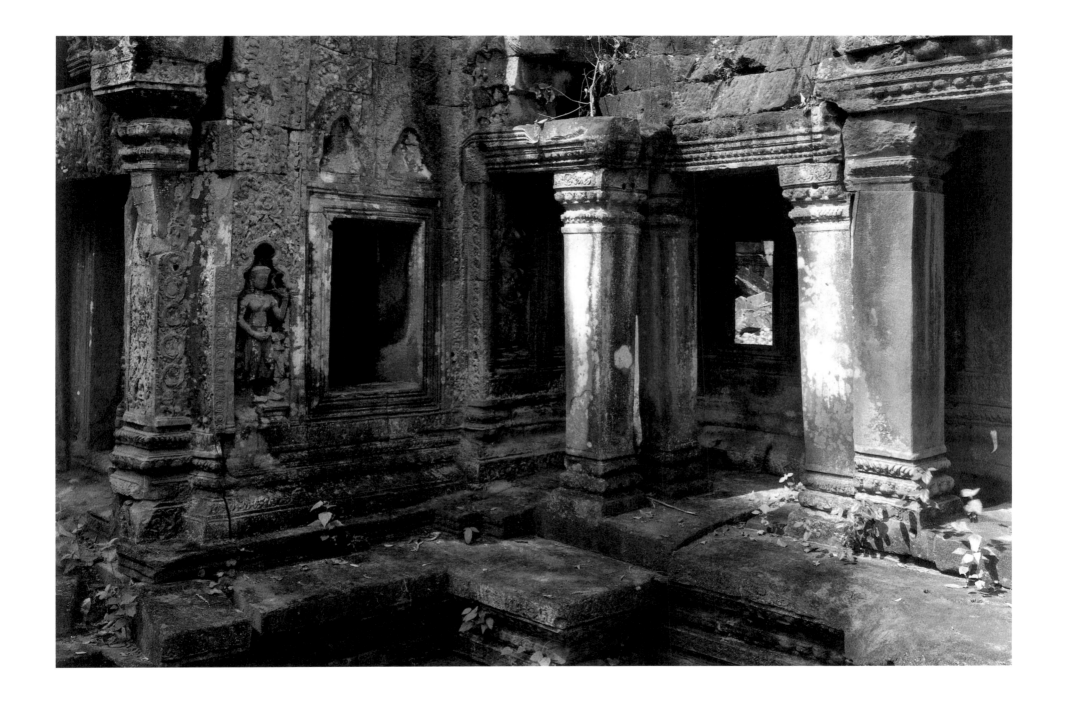

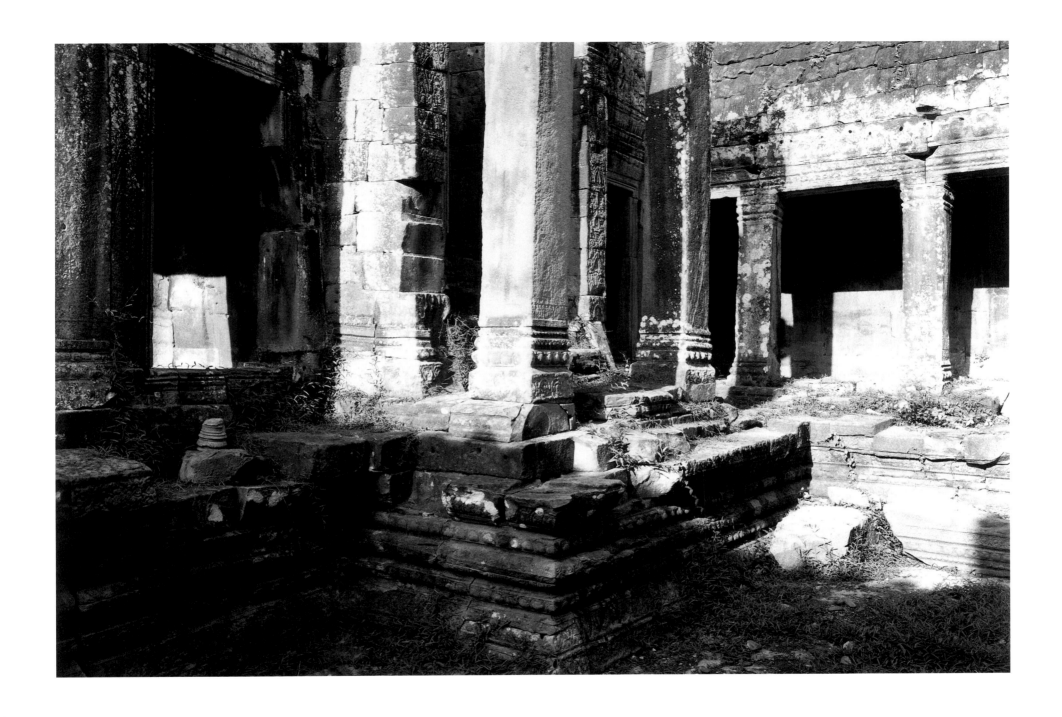

Microcosmic mountain of the gods
For centuries the guardian of the Khmer
Holding forever the secret of our fate,
Eternally enshrined in sleepless gaze.

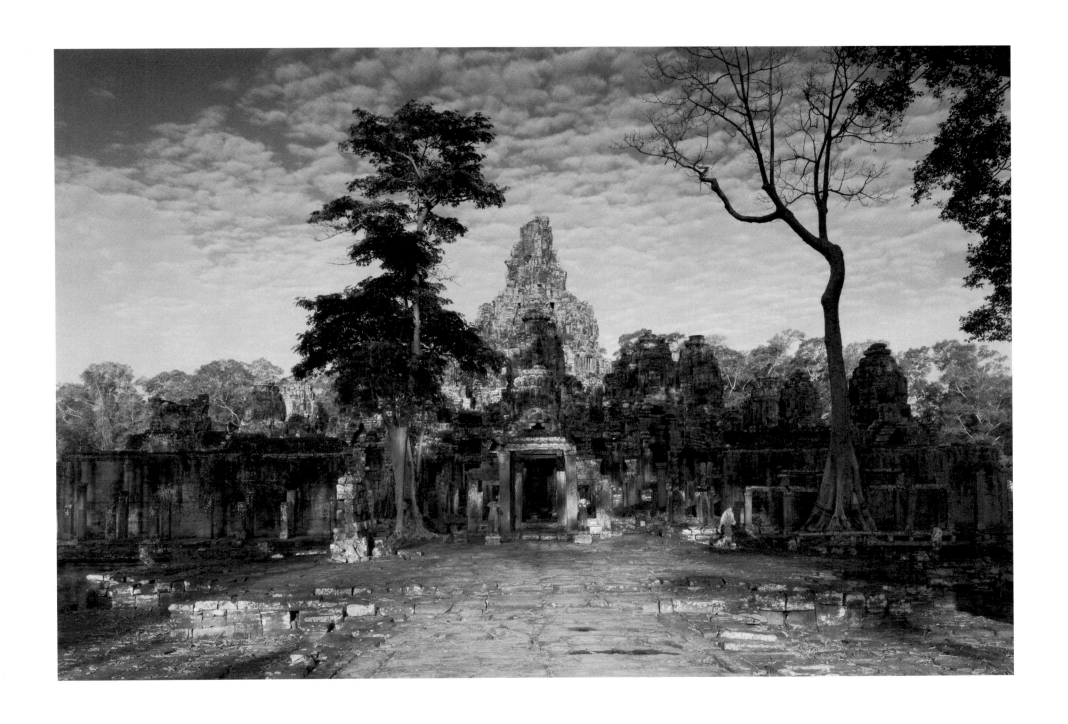

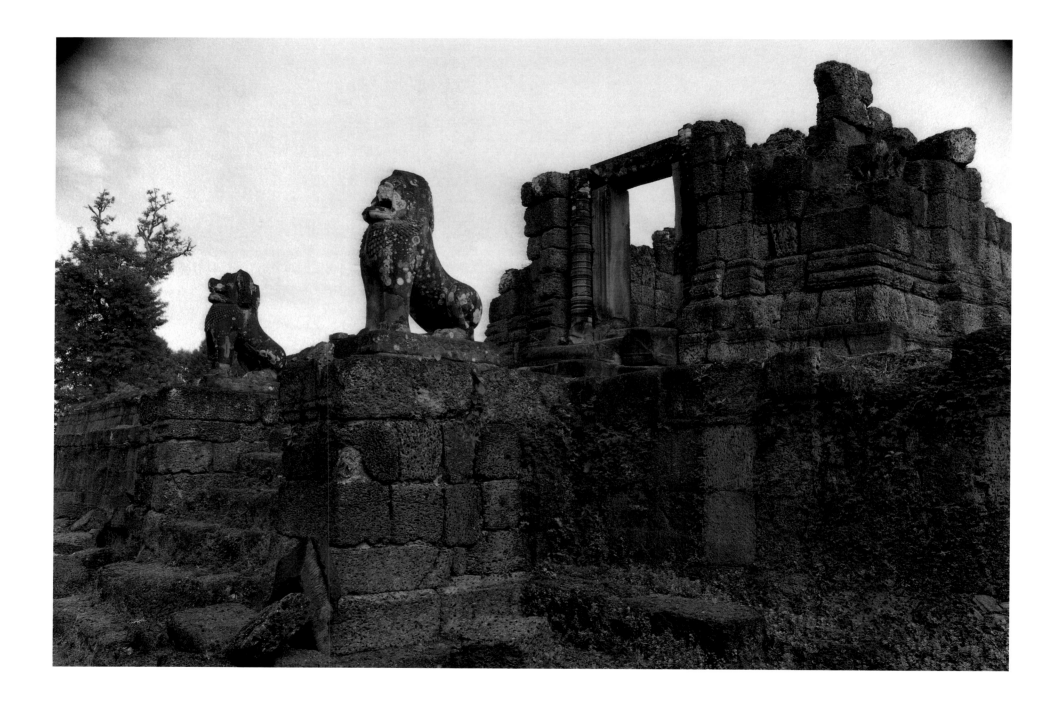

EASTERN MEBON, 1995 ANGKOR NO. 180

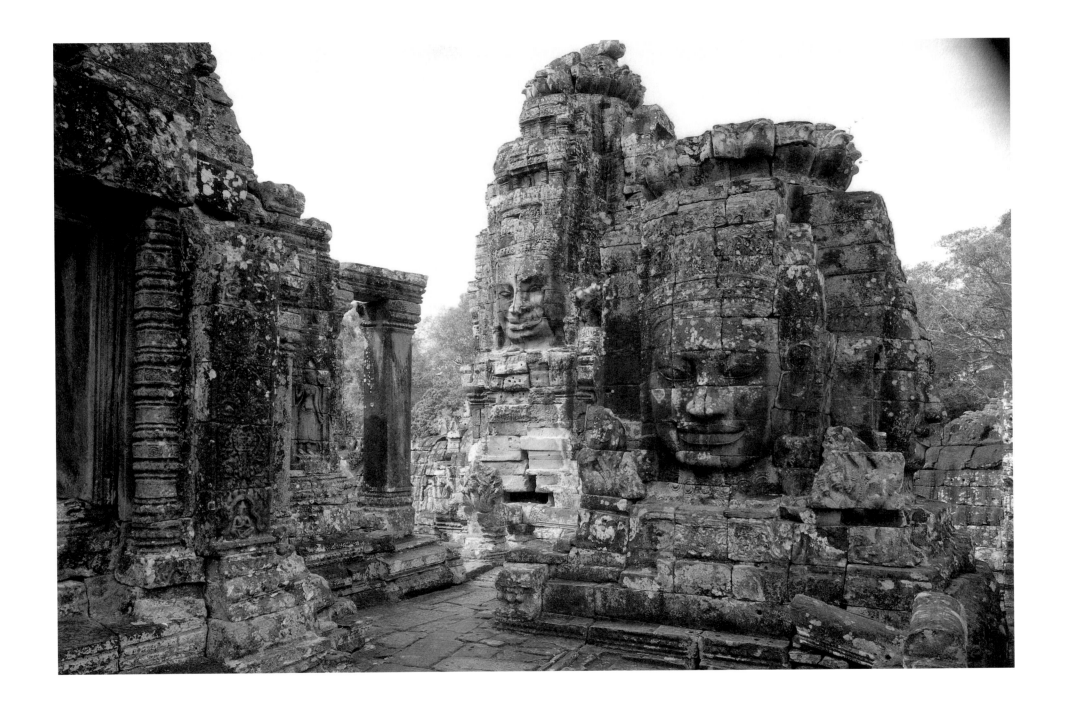

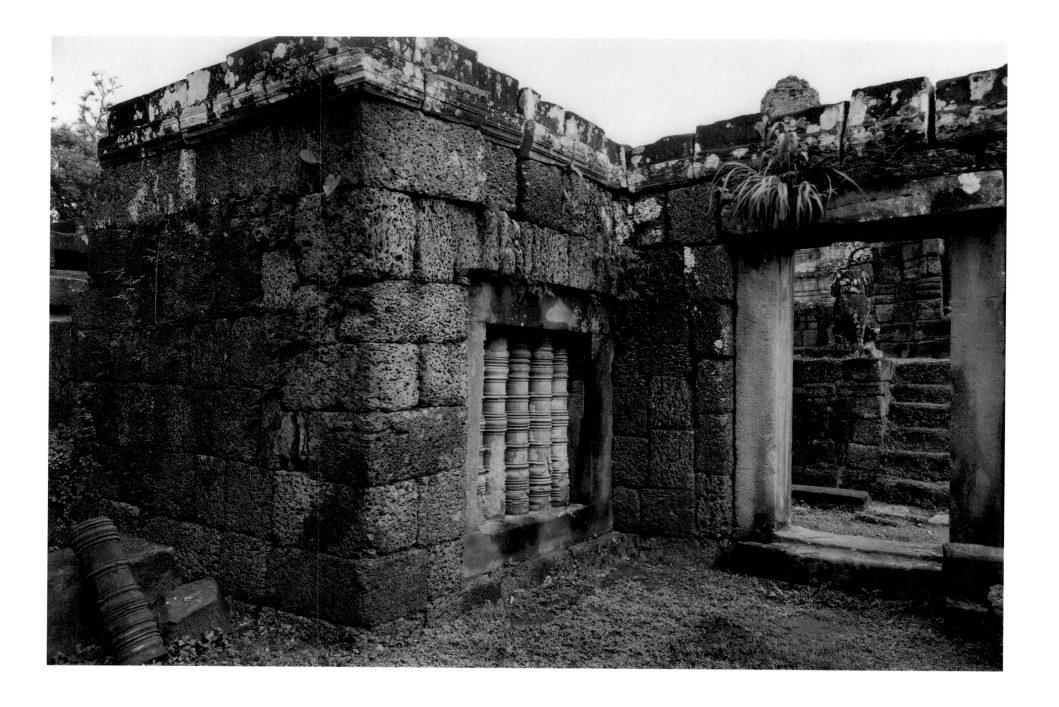

EASTERN MEBON, 1995 ANGKOR NO. 175

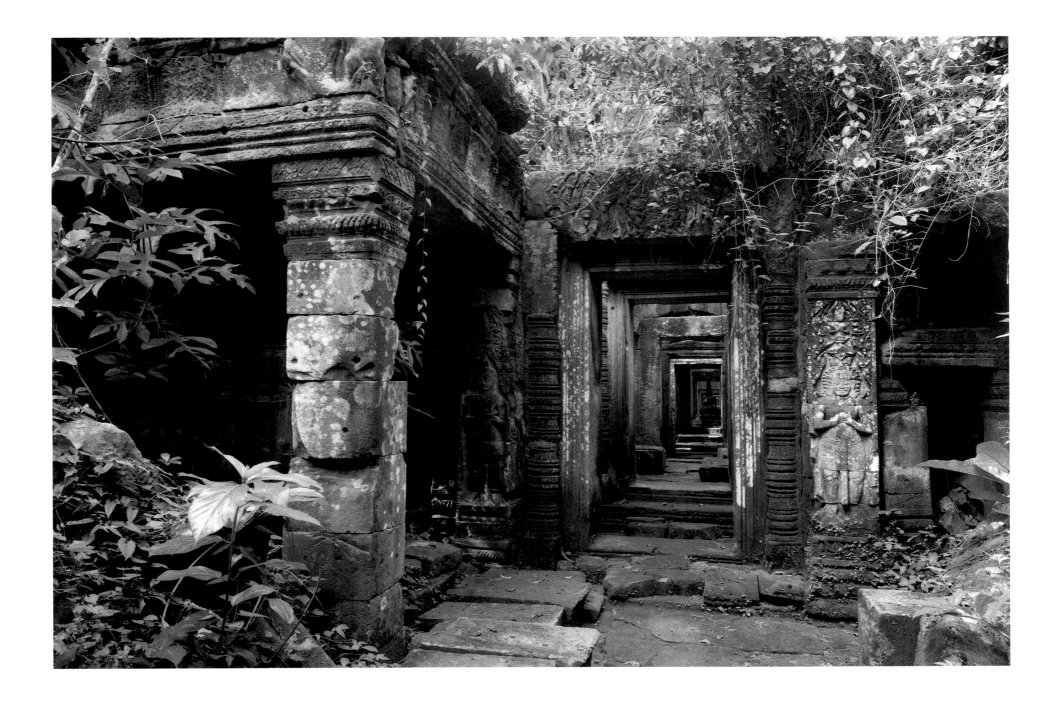

While royal temple guards imperial shades
Unseen the sinuous hair in secret glides
And penetrates the sanctuary's heart.
Insidious roots invade its sacred core
And swell to strangle gallery and tower.

Binding the stone in predatory embrace
The naga coils engulf ambition's halls
And mock the power of overweening kings.
The threads of doubt will penetrate the mind
Presaging silently the fall of man.

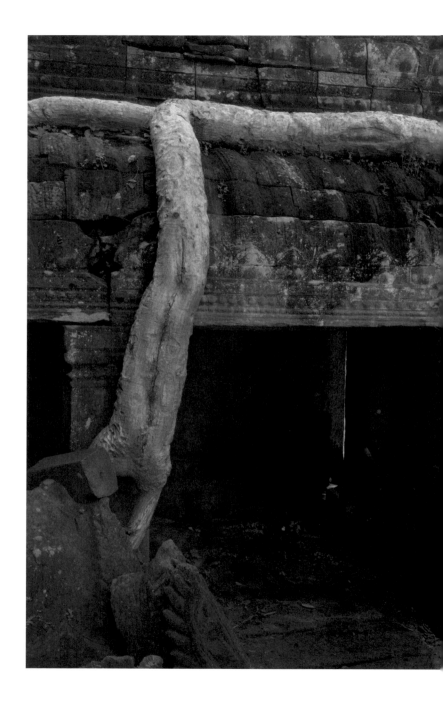

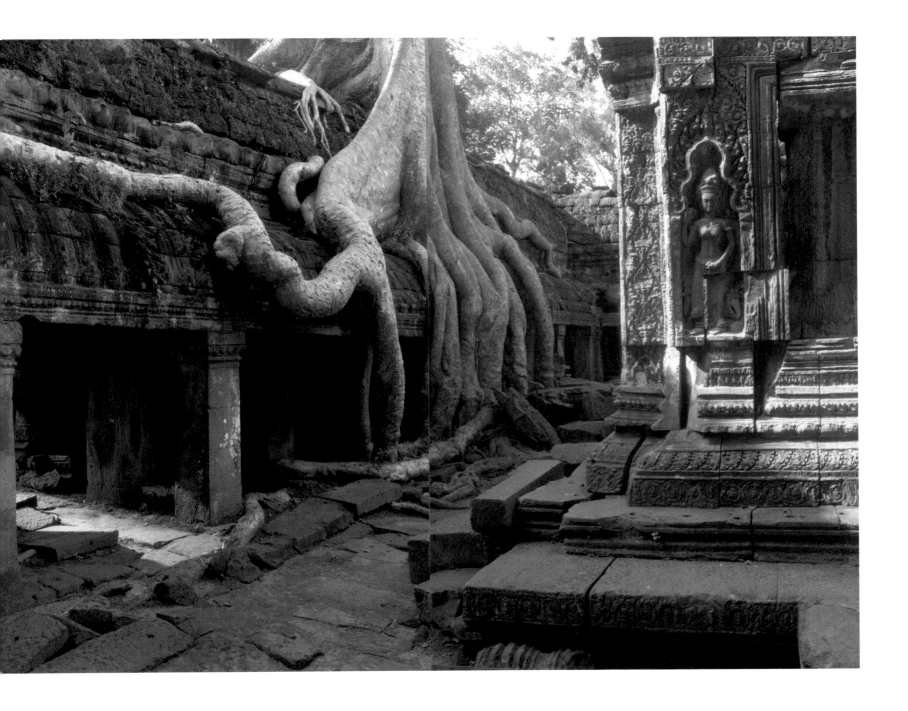

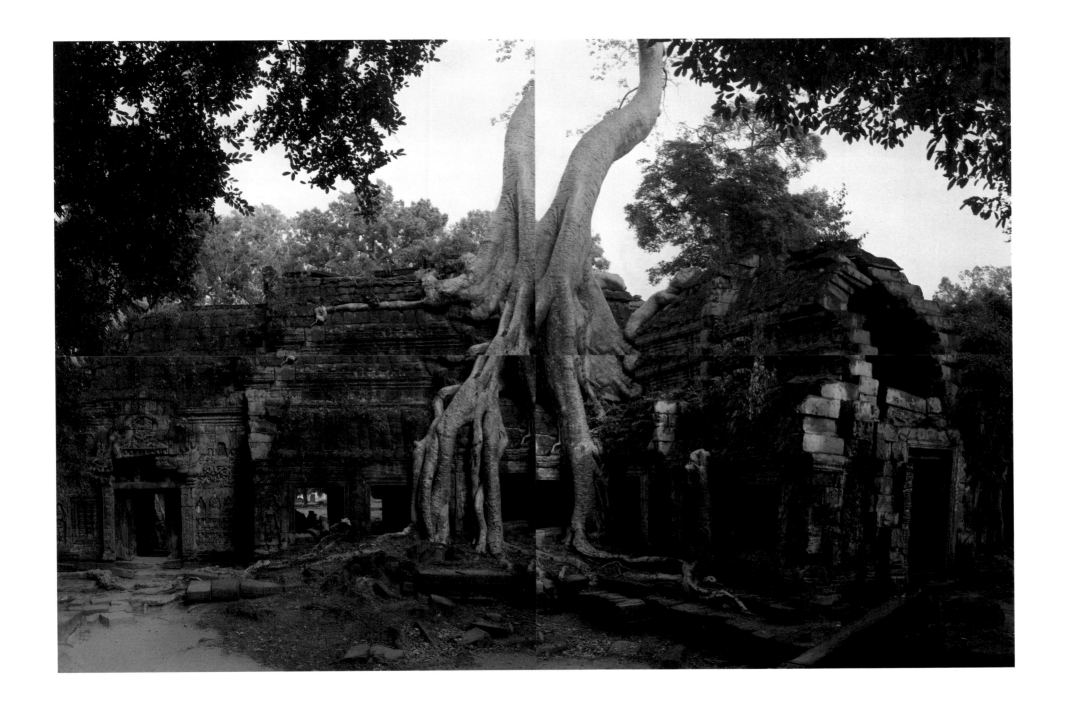

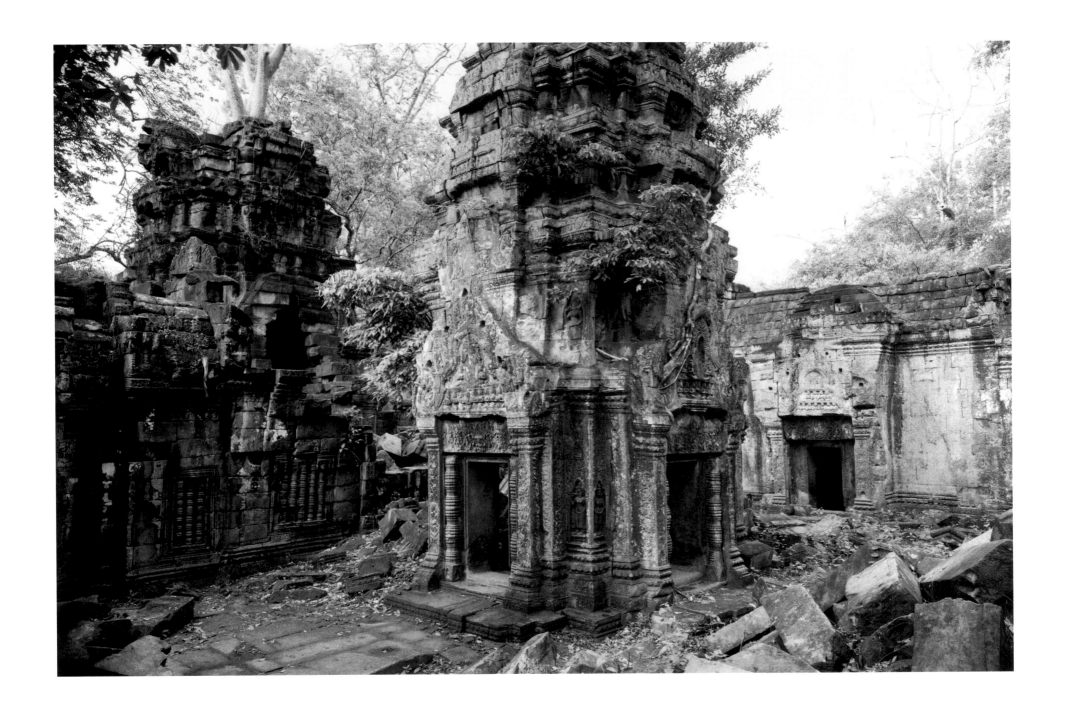

By grace of Vishnu freed from feudal rank
Enjoined to serve another master now,
Colossus braced to counter all attack
Your eagle strength deployed in Buddha's fief,
Garuda, guardian of deities and kings,
Your potent faith will mock the scourge of time.

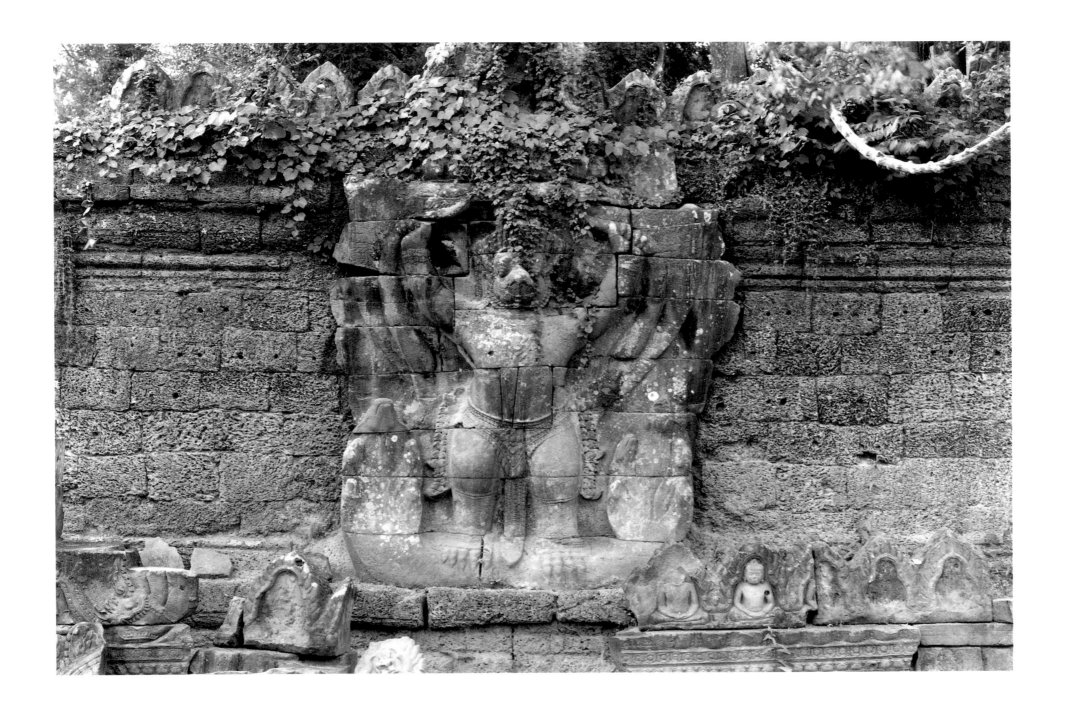

Come, my lord, it is midnight, the naga cried,
I lie in the temple's heart
Awaiting the tryst our ancestors decreed,
Desire for you unslaked.

My coils are milky thighs when moonlight glows,
My hood an effulgent crown.
My serpentine embrace will wind you tight,
Renewing ancient bonds.

You from the land draw strength, and I from water,
My symbiotic love.
Our souls are twined to curb the Furies' threat
That dooms your realm forever.

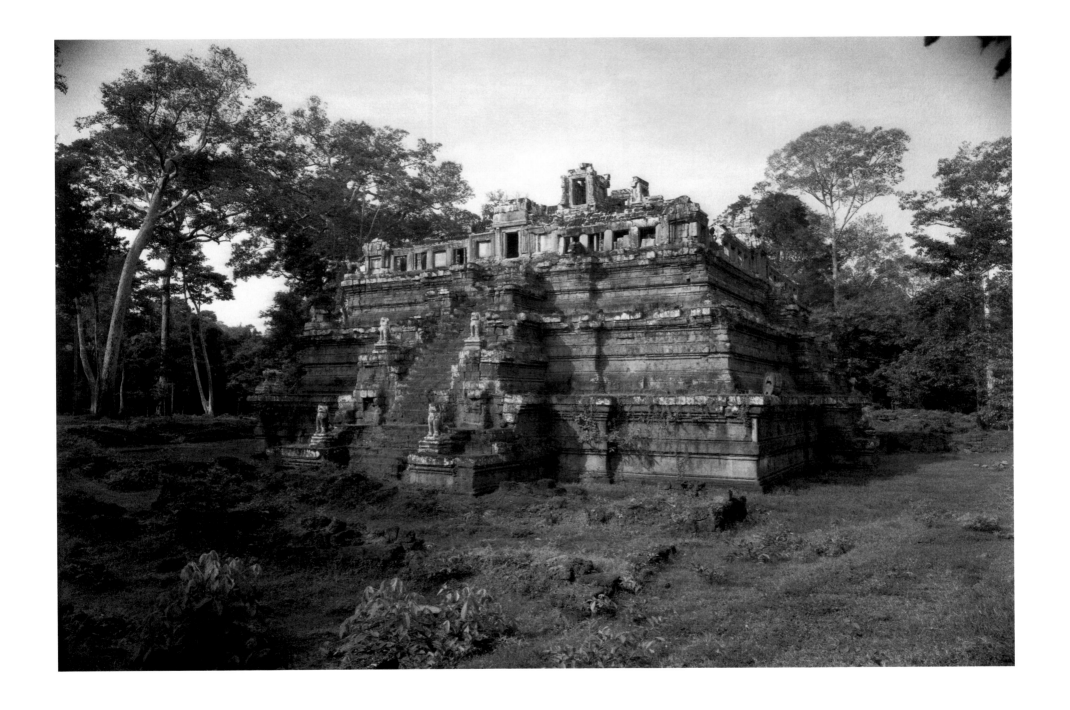

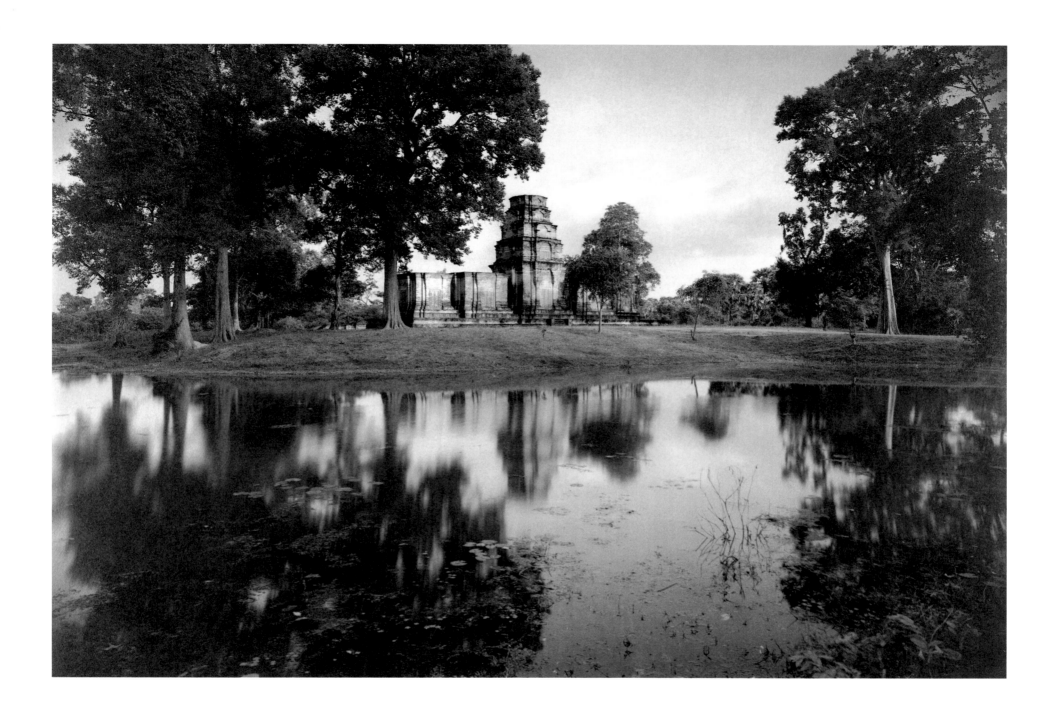

Anavatapta, sacred lake of heaven,
Mother of rivers, elixir for all woes,
Shelter the realm that Jayavarman treasured,
Mirror the boon of Lokeshvara's radiant gaze.

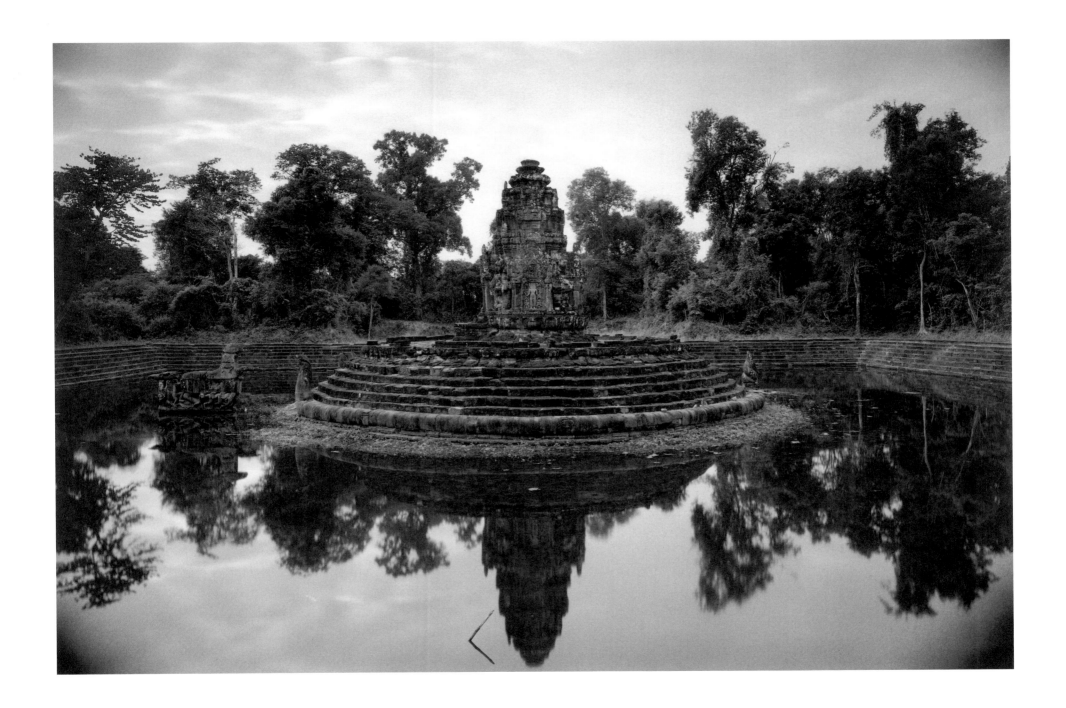

NEAK PEAN, 1994 ANGKOR NO. 120

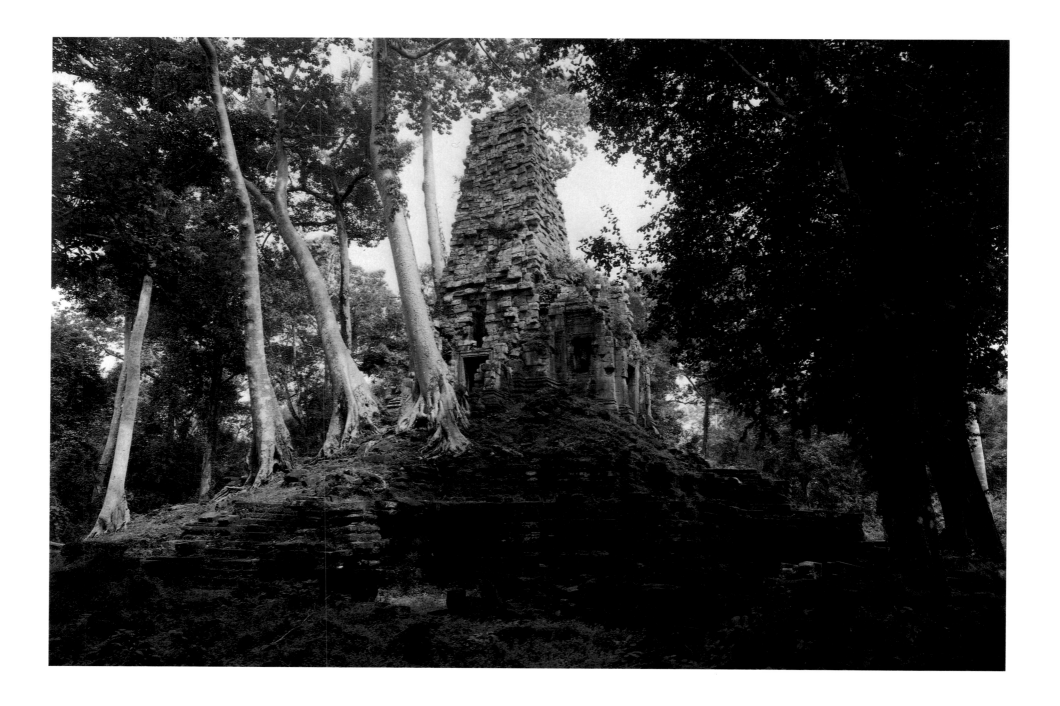

PREAH PALILAY, 1995 ANGKOR NO. 168

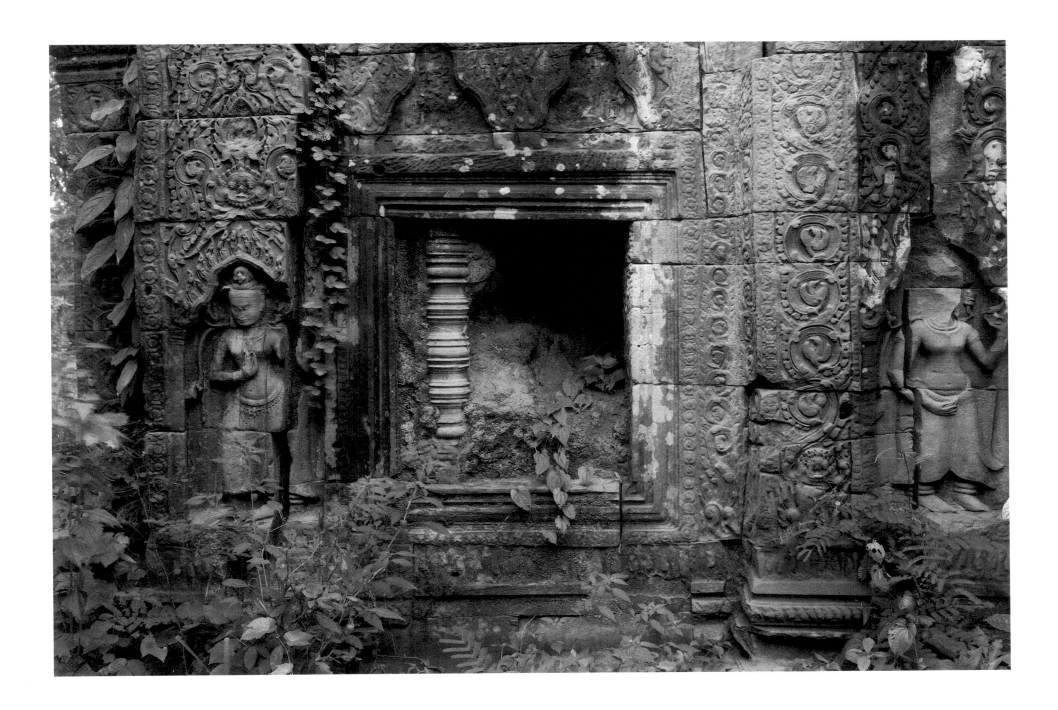

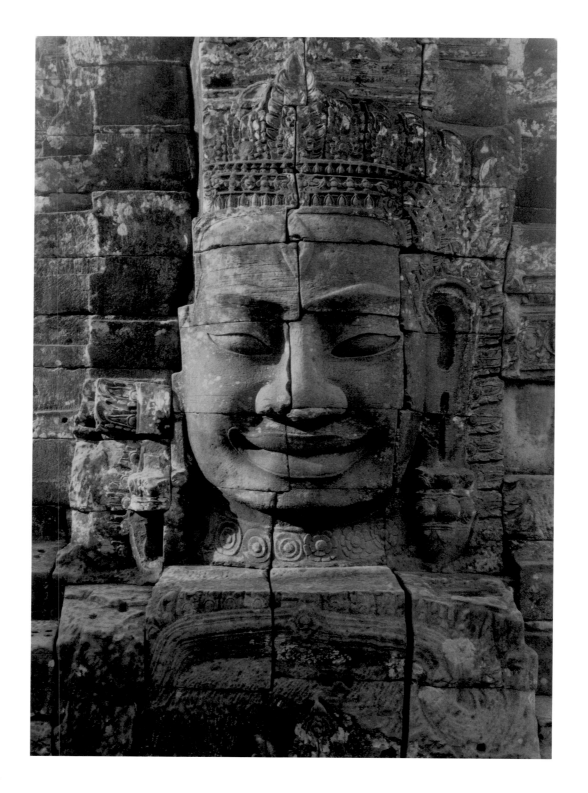

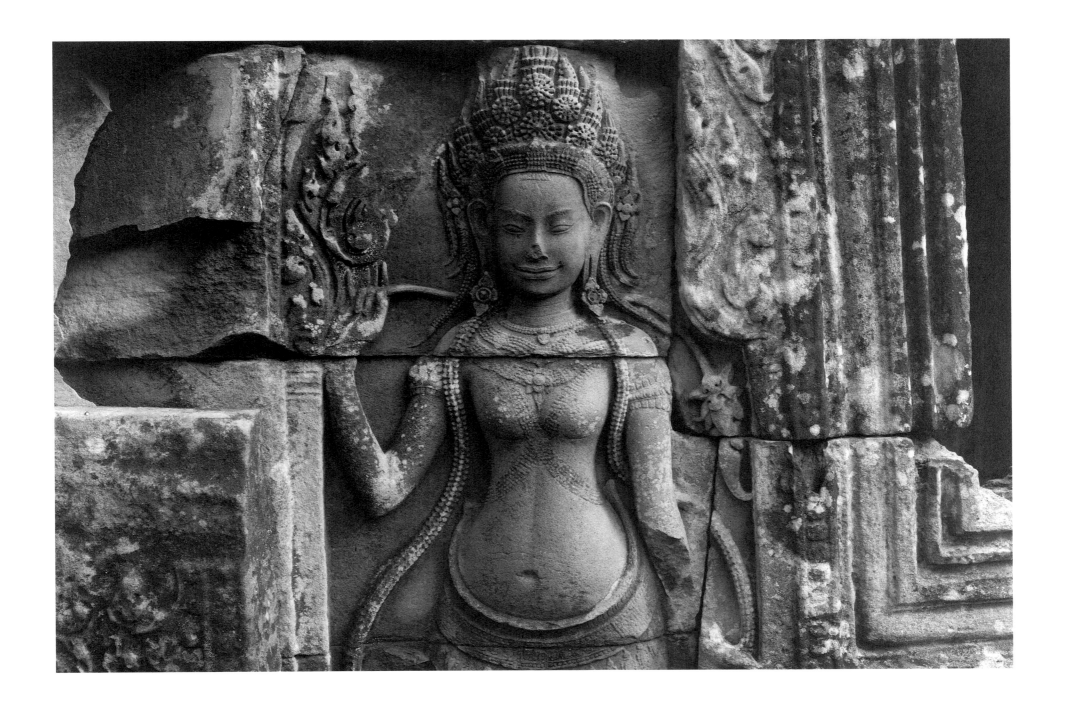

The linga is gone
The altar long forgotten
Yet this living vine.

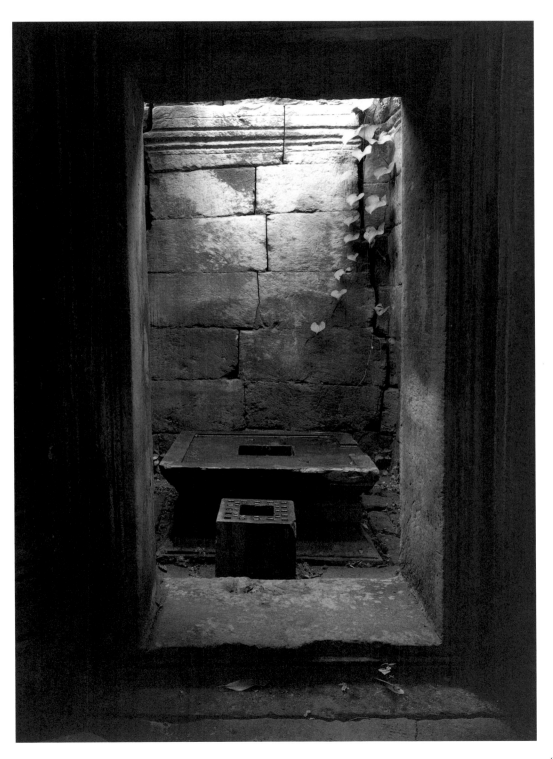

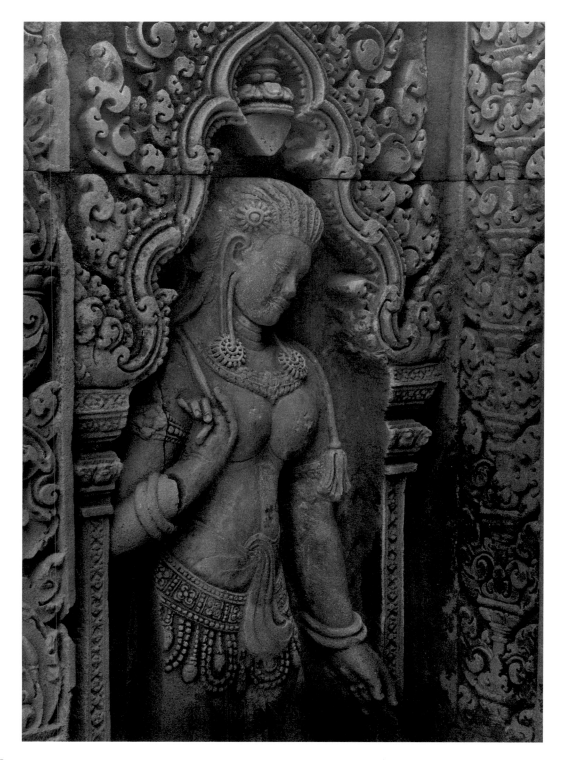

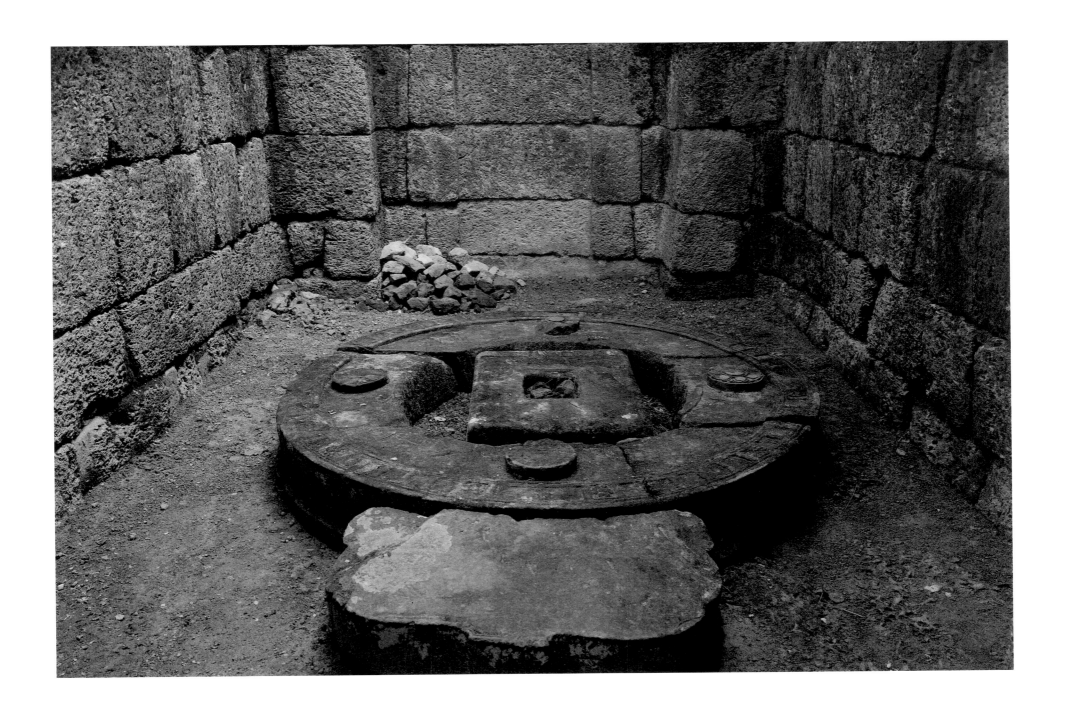

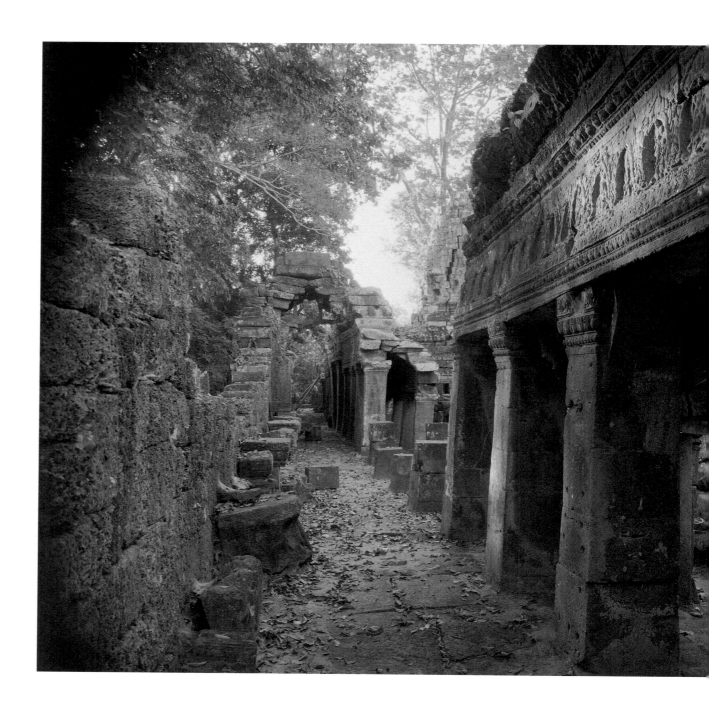

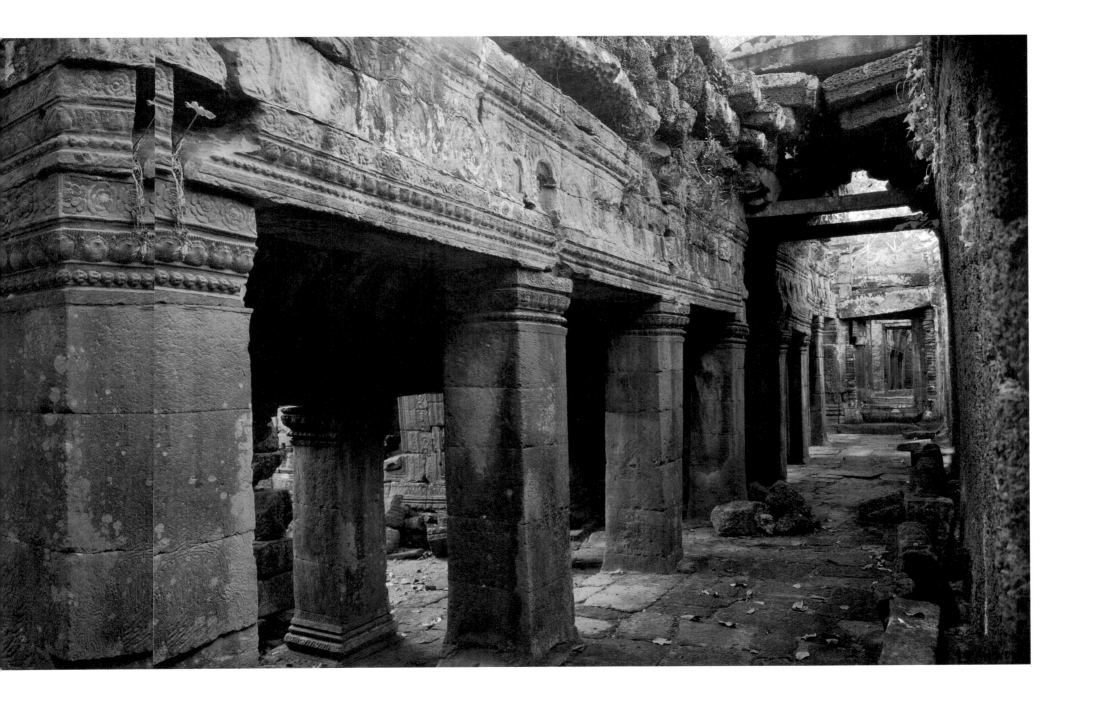

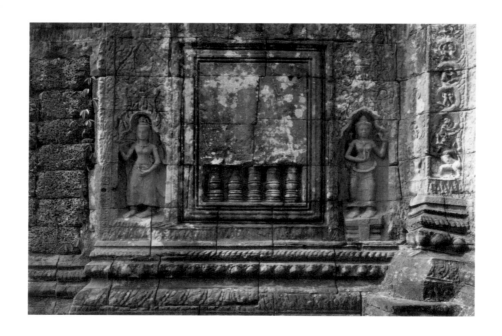

TA PROHM, 1993 ANGKOR NO. 13

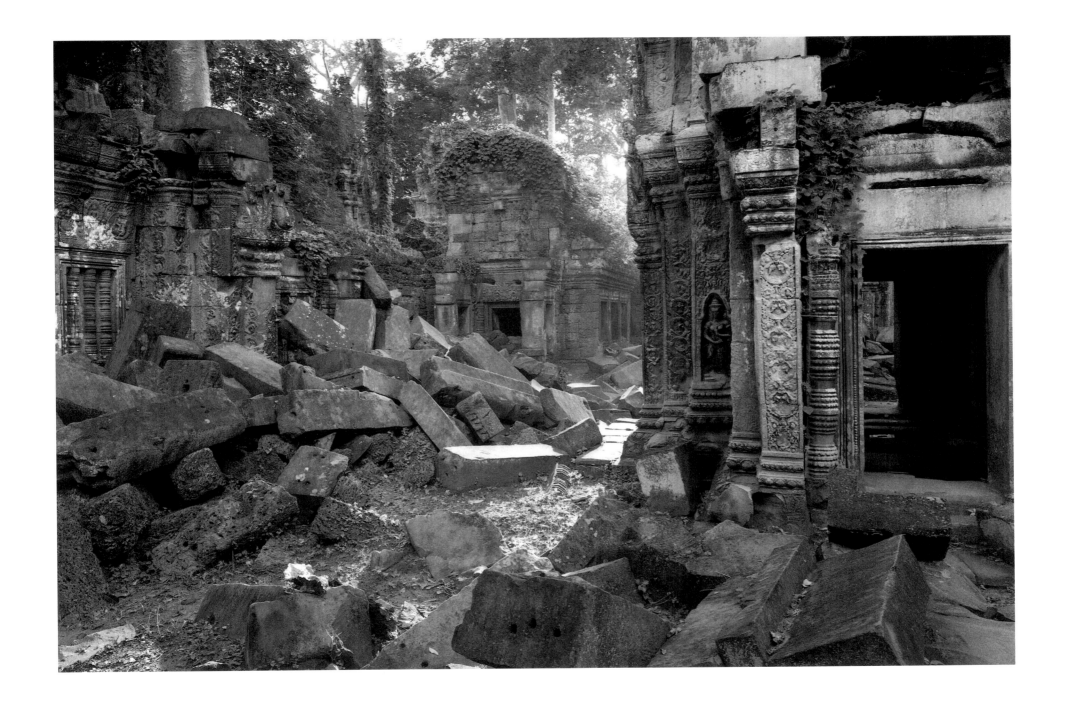

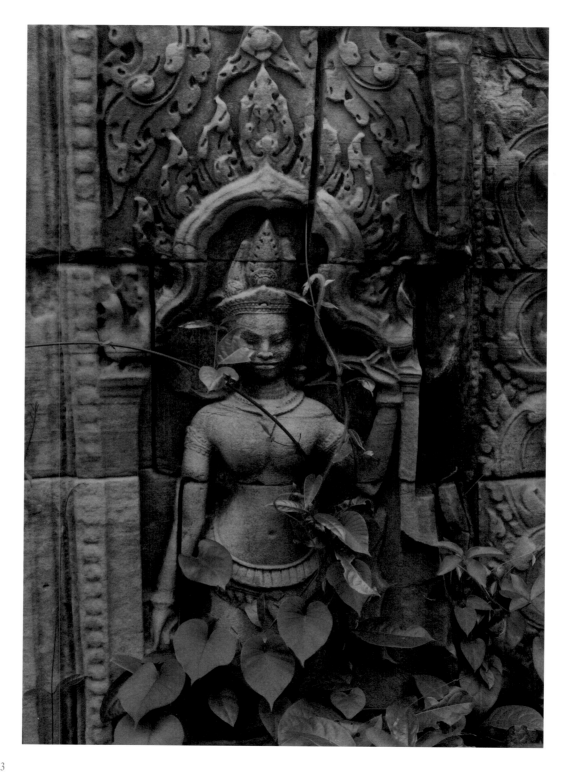

98 TA PROHM, 1995 ANGKOR NO. 193

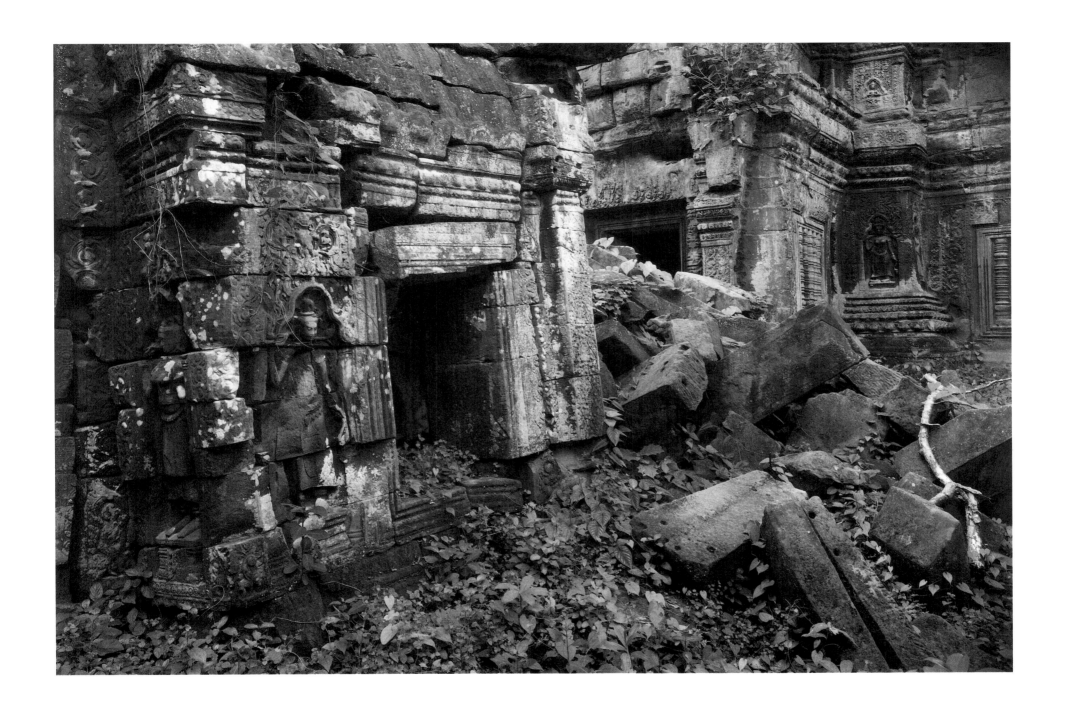

Once you walked with me
The temple's circuit,
Treading the holy way
Around its heart,
Jasmine in your hands
To bless the gods,
Penitence in your soul
From me apart.

Now I walk again
To seek your shadow,
Calling your name aloud
In silent shrines.
The portal held you then
But now is void.
The frame of life will lead
To death's confines.

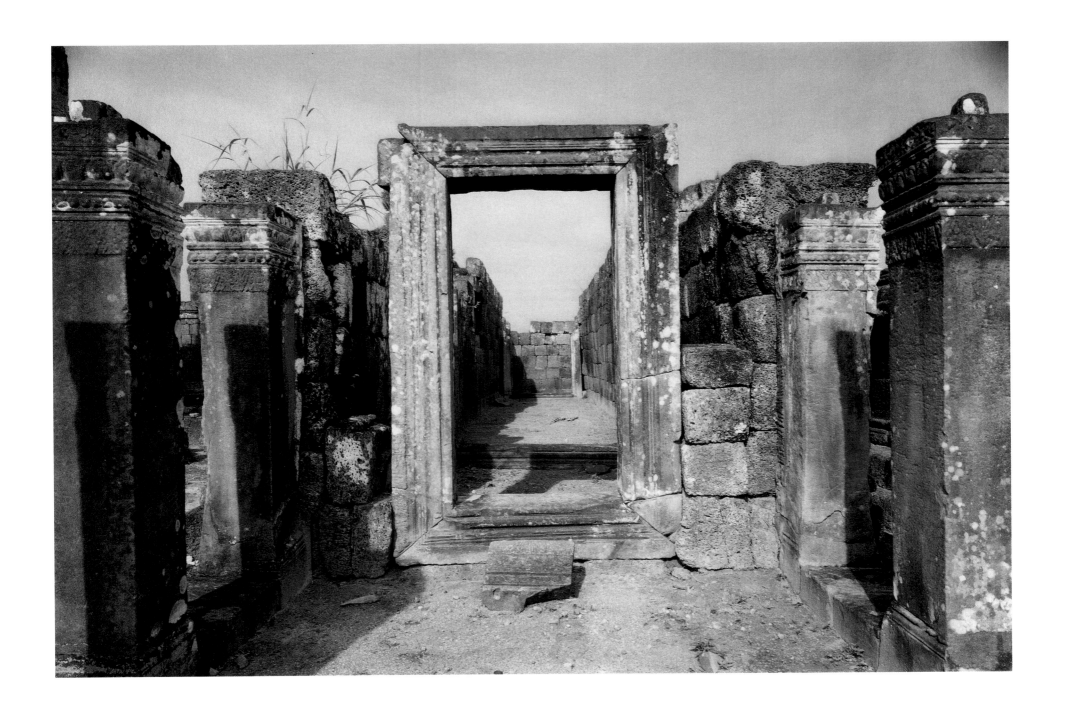

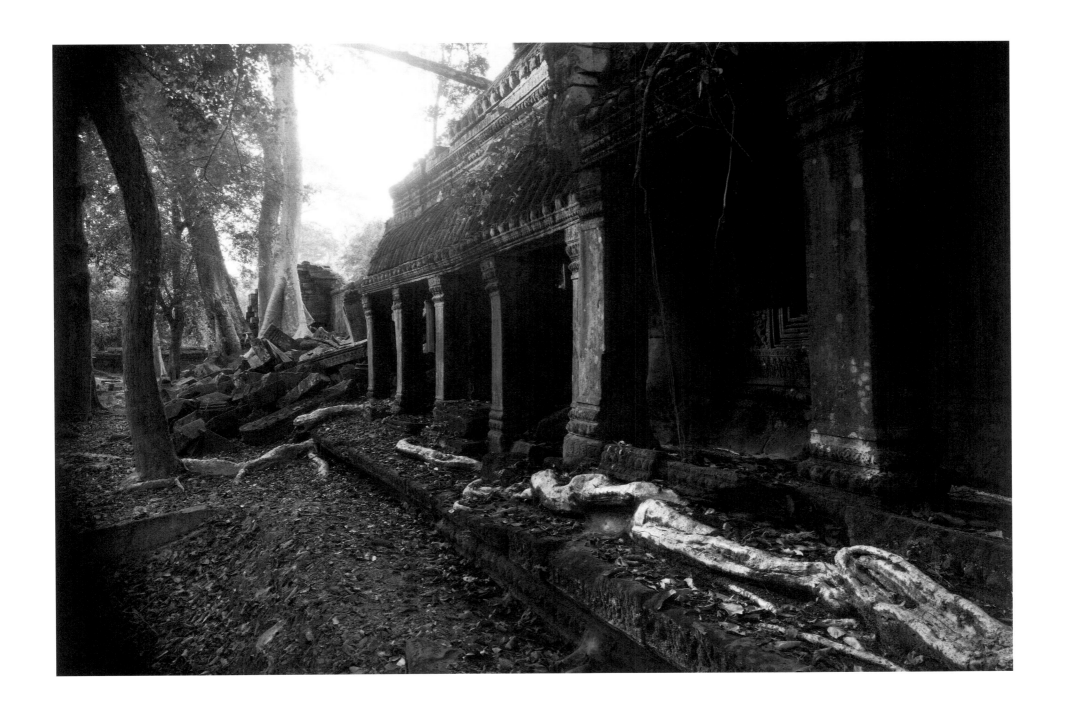

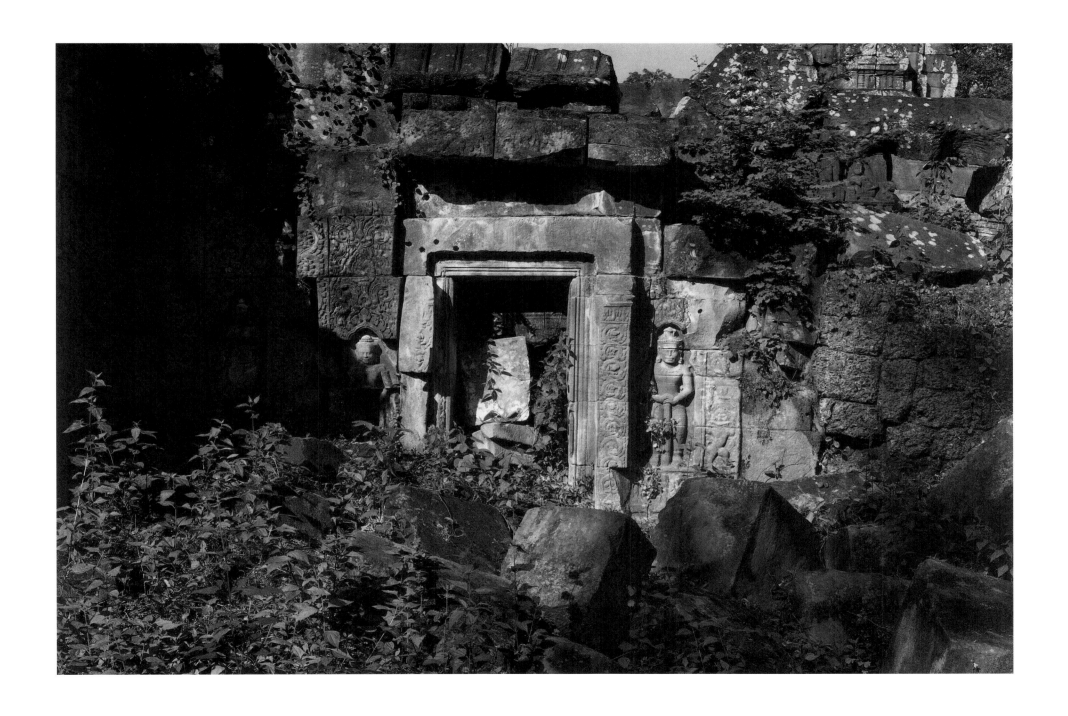

In the dim twilight
Your gaze seeking other truths
Will not close with mine.

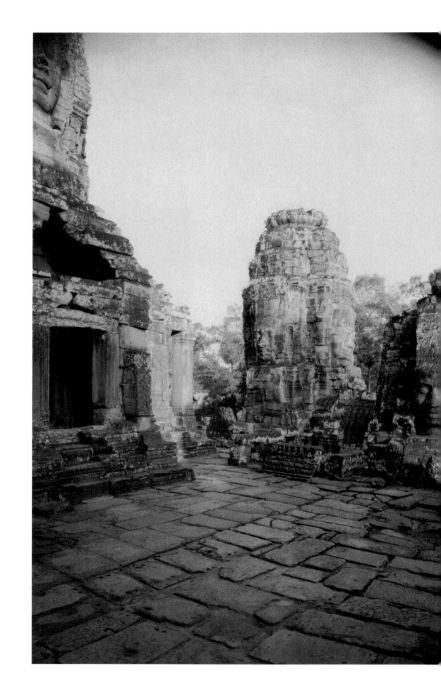

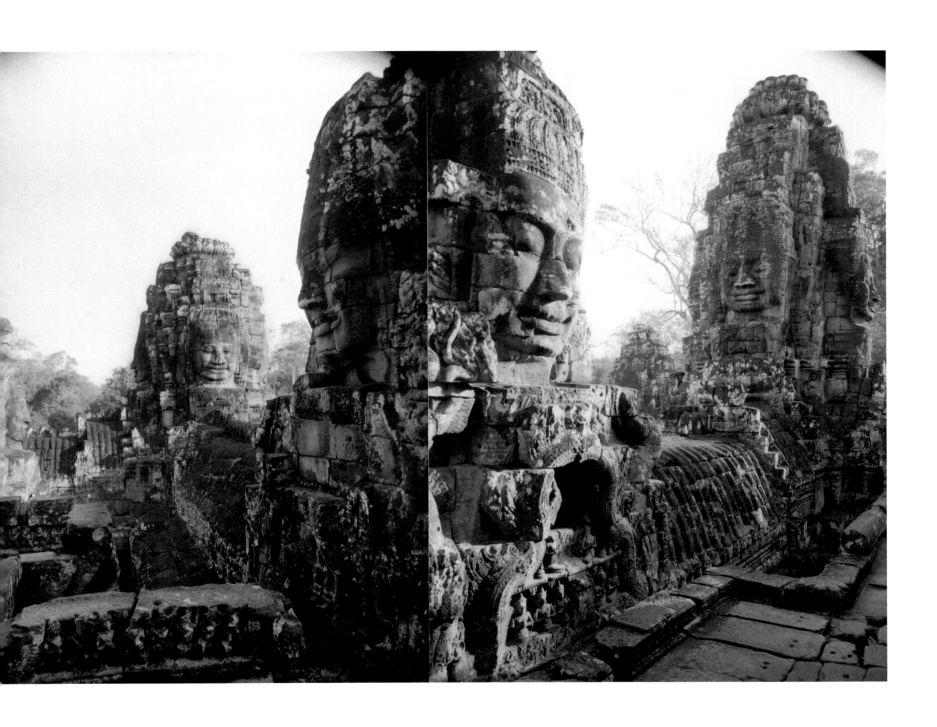

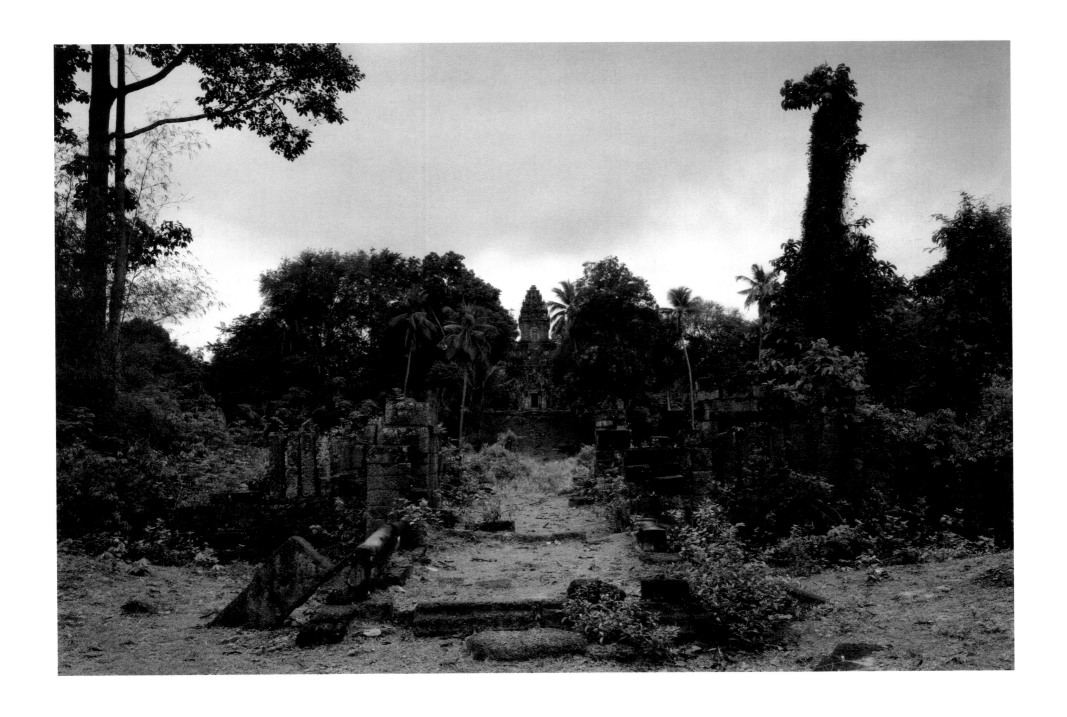

The palm tree whispers
Lotus towers guard his bed—
Vishnu is sleeping.

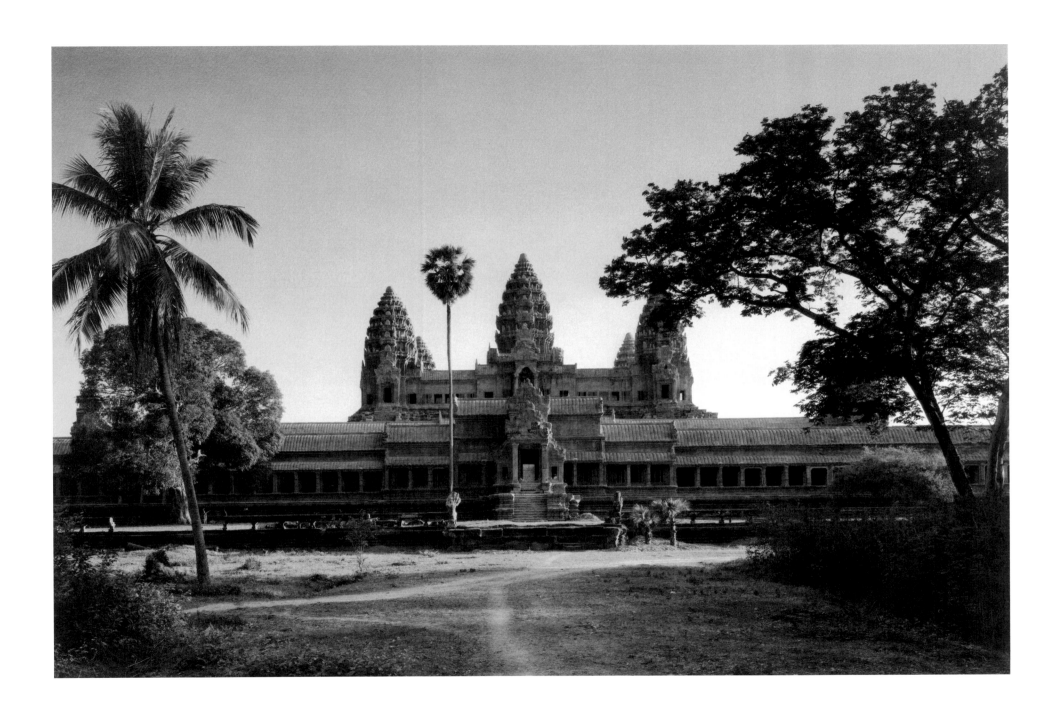

Oh blessed Buddha—
Can your hands dispel my fear?
Abhayamudra.

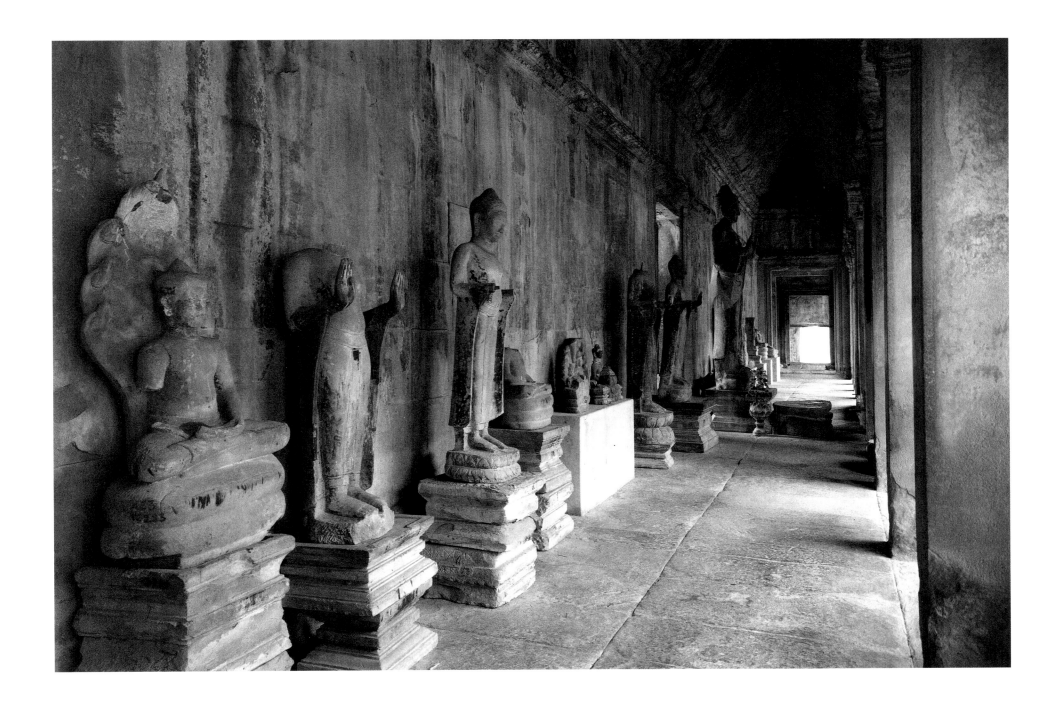

The chariots rumble proudly into battle
The horses scenting blood now neigh in fear.
Their spears held high, the warriors stoke their rage,
Drawing on the sun god's searing light.
Suryavarman's strength protects their charge,
Triumphant Vishnu holds them in his power,
Guardian of his royal vassal's fate.
Frozen in time the army marches on,
The longed-for victory imminent forever.

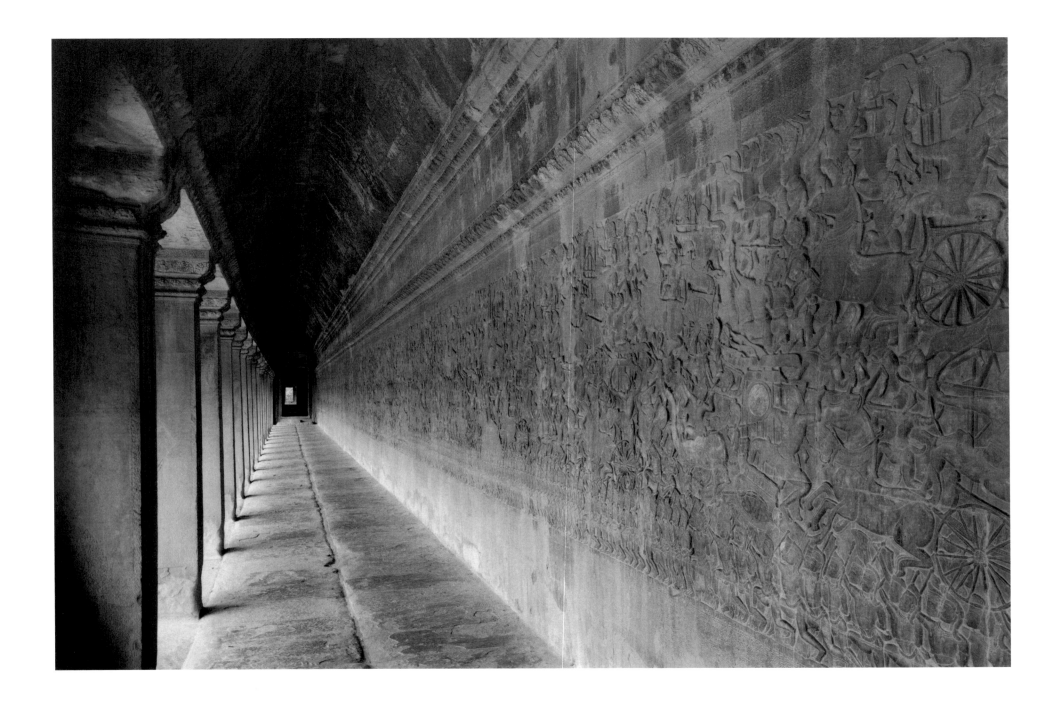

In February 1999, **Angkor Hospital for Children** (AHC) opened offering comprehensive inpatient, outpatient, surgical, intensive care, and emergency services. Outreach programs such as medical assistance for orphanages, home care programs for the chronically ill, testing, care and counseling for sufferers of HIV/AIDS, dental and ophthalmologic services are also provided. Through 2005, more than 300,000 children have been treated and more than 5,500 surgeries performed.

Equally important, AHC's **Medical Education Center** is working to rebuild the devastated state of Cambodian health care, a legacy of the brutal Khmer Rouge regime which ended in 1979. AHC is one of only two sites in Cambodia responsible for Integrated Management of Childhood Illness training, a program developed and endorsed by the World Health Organization, UNICEF and the Cambodian Ministry of Health. In 2004, over 1,000 Cambodian health workers, representing various medical specialties and regions of Cambodia received training.

Through our **Capacity Building and Health Education Program** (CBHEP), we go beyond the walls of the hospital to rebuild the capacity of staff at regional government health centers, and to work directly with the community to educate residents about nutrition, hygiene, and other health issues. By emphasizing prevention in community education, CBHEP is able to reduce the incidence and severity of illness.

All proceeds from the sale of this book support **Angkor Hospital for Children.**

Friends Without A Border is a not-for-profit corporation under sections 501(a) and 501(c)(3) of the Internal Revenue Code. The good work of Friends Without A Border clearly demonstrates our guiding principle—*among friends, there are no borders.*

Contact for further information:

FRIENDS
WITHOUT A BORDER

1123 Broadway, #1210
New York, NY 10010
(212)691-0909
fwab@fwab.org
www.fwab.org

Produced by FRIENDS WITHOUT A BORDER

Copyright © First Friends Without A Border edition, 2005
Originally published by Channel Photographics LLC in 2003

Image, page 3: *Angkor Wat, 1993 Angkor #4*
Image, page 7: *Preah Kahn, 1996 Angkor #239*
Image, page 8: *Bayon, 1996 Angkor #246*
Image, page 60: *Angkor Wat, 1994 Angkor #136*

> A note regarding the poems on pages 14, 50, 90, 106, 110, and 112:
> The haiku were written in tribute to Kenro Izu's art and ideals. The author is deeply indebted to Andrew Pekarik for insights into the iconic elegance of this deceptively simple form.

Project consultant: James Crump
Art direction and design: Elsa Kendall

Distributed by SCB DISTRIBUTORS
15608 South New Century Drive
Gardena, CA 90248-2129
phone 310/532-9400 fax 310/532-7001

Printed by Meridian Printing, East Greenwich, Rhode Island

ISBN: 0-9653574-7-3